Seeing through "paradise"

artists and the Terezín concentration camp

D0132312

Organized by
Massachusetts College of Art
Boston, Massachusetts

Acknowledgements

The Massachusetts College of Art and the curators of *Seeing through "paradise"* wish to extend their sincere gratitude to the following individuals and organizations for their valued contributions to this exhibition. In particular, we are grateful to Henry Isaacs, who initiated this project, to Arno Pařík, of the State Jewish Museum in Prague, whose scholarly and curatorial assistance were invaluable, and to the Goethe-Institut Boston, and its director, Dr. Peter Schmitt, who have encouraged and supported this project from its beginning.

Special thanks to Dr. Robert and Jane Tublin, as well as the Lawrence and Carol Zicklin Philanthropic Fund. Their generosity has made it possible to return these drawings to Czechoslovakia in their present matted and framed condition — a true gift to posterity.

Fritta/Fritz Taussig
View of Terezín, 1943-4, pen and India ink, paper, 59.3 x 44 cm, State Jewish Museum, Prague

4

Major Contributors

Sandra and David Bakalar
Milton and Anne Borenstein
Jessie and Vernon Branson
Lillian and Harry Freedman
Goethe-Institut Boston
Barbara and Steven Grossman
Harold Gurwitz
Houghton Mifflin Company
The Jaffe Foundation
Jewish Welfare Federation of Detroit
Lufthansa Airlines
Massachusetts College of Art Foundation, Inc.
Massachusetts Cultural Council
Sue and Dan Rothenberg
Netty and Maurice Vanderpol

This catalogue is supported in part by a grant from the Massachusetts Foundation for Humanities, a state program of the National Endowment for the Humanities, and by the Massachusetts Cultural Council, as administered by the Boston Arts Lottery Council.

Institutional Support

The American Jewish Joint Distribution Committee, New York, Denise Bernard Gluck, *Director of Archives*

Beit Theresienstadt, Israel, Alisa Shek

Czech and Slovak Federal Republic Embassy, Washington, DC, Rita Klímová, *Ambassador*, Jiří Šetlík, *Cultural Attache*

Facing History and Ourselves Foundation, Margot Stern Strom, *Director*

F.O. Matthiessen Room, Eliot House, Harvard University

Ghetto Fighters' House, Israel, Monia Avrahami, *Director*

International Red Cross, Geneva, Francoise Perret, *Chargé de Recherches, Doctrine, Droit, et Relations avec le Mouvement*

Leo Baeck Institute, New York, Robert A. Jacobs, *Executive Director*, Jacqueline Rea, *Art Curator*

Museum of Jewish Heritage, New York, Deborah Dawson Wolff, *Assistant Director for Museum Programs*, Elaine Vogel, *Registrar*

National Center for Jewish Film, Brandeis University, Sharon Rivo, *Executive Director*, Mimi Krant, *Associate Director*

State Jewish Museum, Prague, Ludmila Kýbalová, *Director*, Bedřich Nosek, *Head of Collections*, Arno Pařík, *Curator*

Tauber Institute for the Study of European Jewry, Brandeis University Sylvia Fuks Fried, *Assistant Director*

Terezín Monument, Jan Munk, *Director*, Jiří Janoušek, *Deputy Director*, Jiří Brabec, *Curator*

United States Embassy in Prague, Shirley Temple Black, *Ambassador*, Helena Ackerman, *Press and Culture*

United States Information Agency, Lorie J. Nierenberg, *Assistant General Counsel*

Yad Vashem, Jerusalem, Irit Salmon-Livne, *Chief Curator*

Scholarly Assistance

Mary Curtin-Stevenson
Lucy Dawidowicz
Helga Hošková
Christine Kodis
Arnošt Lustig
Karl Margery
Marianne Zadiková May
Sharon Rivo
Ruth Schwertfeger
Peter Spier
Mark Talisman
Frederick Terna
Beeke Sell Tower
Dan Weissman
Thomas Winner

Friends

Richard S. Blacher
Margaret and Jeffrey Borenstein
Joan Boyden
Phyllis and Roy Brown
Keith Brumberg
David C. Carr
Edward W. Clark and Jack Sheinkman, ACTWU
Beverly and Sheldon Cohen
Consulate General of Israel
Congressman Silvio Conti
Marjorie Cotton
Lisa DeFrancis
Andrew S. Dibner
Julie and Ronald Druker
Kitty Dukakis
Stephen Dyer and Anthony J. Hartman
Dan Eisenberg and Ellen Rothenberg
Sam and Avril Ellenport
Linda Forslund
Freilach Band
Lev Friedman
Michael W. Gery
Jonathan P. Gill
Roz Gorin
Haymarket People's Fund
Senator Ted Kennedy
Earl E. Hellerstein, MD
Herbert Hoffman
Senator John Kerry
Judy Kohn
Barbara N. and Arthur R. Kravitz
Lizabeth and George Krupp
Judi and Douglas Krupp
John Ladner
Mark Ludwig
Robert E. MacIntosh
Elena Makarova
Masaryk Club of Boston
William Mencow
Sara Jane Miller

Judith Moncrieff
Maude Morgan
Barbara Murville
Marvin Myers
Karen Papineau
Jonathan Pucker
Sue and Bernard Pucker
Marilyn Richardson
June and Norman Rosenberg
Linda Ross and Dean Nimmer
Sharon Seltzer
Elaine and Samuel Sepinuck
Enid and Mel Shapiro
L. Dennis Shapiro
Anna Sladkova
Marshall Smith
Richard Smith
Krisha Starker
Kenneth Totah
Ziona and Oswald Treisman
Deborah B. and Leonard Tucker
Lilla M. and Mark J. Waltch
Carol R. Warner
Jay Weinstein
George Abbott White
Paula and Bill Zellen

Business Support

Bernard Michals Insurance Agency
Boris Mastercolor
Charette Corporation
Continental Cablevision, Cambridge
Fine Arts Express
Harcourt Bindery
Hasenkamp International
The Kolbo Gallery
Monadnock Paper Mills, Inc.
The Old Cambridge Company
Pilgrim Parking
Pucker-Safrai Gallery
Sotheby's, New York

Massachusetts College of Art

William F. O'Neil, *President*
MCA Board of Trustees
MCA Alumni Association
Richard Aronowitz
Claudine Bing
Kevin Bird
Roy Brown
James Cole
Patricia Doran
Stephen Farrell
Kenneth Fitzgerald
Mary Gagliano
Diane Hayes
Abigail Housen
Diana Korzenik
Susan Lane
Elizabeth Mackie
Marianna McCormick
Christy Park
James Williams

Student Assistants

Porter Arneil
Barbara Barry
Jennifer Dunham
Ruth Ellis
Jeorg Fraske
Sara Rose Gravante
Mark Matthews
Lourdes Romao

And many other friends and supporters.

5

Seeing through "paradise"

The visual images in this exhibition *Seeing through "paradise:" artists and the Terezín concentration camp*, from witnesses and sufferers during a terrible era in mankind's history, speak for all of us as well as for themselves. They show the persistence of the need to turn even the most devastating experiences into affirmations of stubborn strength of will and of human creating power, to affirm a faith that there is human feeling that can be reached beyond the brutality of present existence.

We all now know, as these witnesses only guessed, that there were camps that were far worse than this one. The men, women, and children interned in this camp could retain their humanity and stay alive much longer than the inmates of Treblinka, Auschwitz-Birkenau, Sobibor, Buchenwald, Dachau and many other extermination camps. Within the camp/ghetto system, the conditions at Terezín were unique. But just staying alive was not enough. They needed to see, to think, to compose music, poems, drawings, paintings, theatrical pieces, operas, essays, memoirs. They continued to think of themselves as civilized human beings leaving messages for the future.

We at the Massachusetts College of Art are presenting these visual messages to the world, as the artists had intended. All of us involved in this project have felt from the beginning of our awareness of the existence of these works of art that there was an urgent need to show them, to allow people to see the power and skill of the artists. We are grateful to the individuals and organizations that have helped us bring them to you.

Project Directors

Johanna Branson
Michèle Furst
Jeffrey Keough

Terezín Exhibition Committee

Betty Buchsbaum
Marjorie Hellerstein
Henry Isaacs
Allan Mietla
Heddi Siebel
Jonathan Silverman
Irene Portis-Winner

Project Assistants

Thomas Linfield
Roseanne Rizzi
Celia Shneider

6

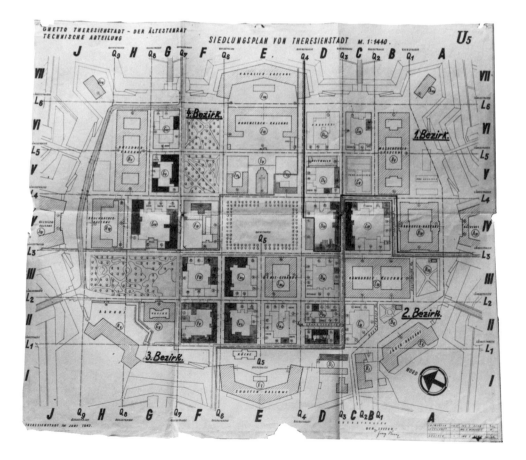

A unique educational opportunity

Margot Stern Strom, *executive director*,
Facing History and Ourselves Foundation

Every art exhibit is a unique educational opportunity. We have the opportunity to view the world of an artist and to understand that we all see events, people and objects differently. By its nature, art gives us permission to express opinions, to interpret the world through our own lenses—from our culture, our family backgrounds, our educational experiences, our unique selves. Art is a tool for critical thinking. It encourages us to think originally, to seek our own answers, not to search for the right one or to puzzle out someone else's answer.

The voice of the artist is often the first silenced when a totalitarian regime takes power. The artists of Terezín were not only silenced but then turned into victims who were forced to help their victimizers by perpetuating the "big lie" that the Nazi regime was benign and humanitarian. Their courage in secretly documenting their experience brings wisdom to us not only by letting us observe their experience but by documenting the horrors of the failure of democracy. The fact that they were victimized in this way tells us the extent of the deceit— the whole public was deceived and the artists were forced to help in the deception.

It is particularly appropriate for Facing History to be a part of this important exhibition. Our mission is to provide teachers with the tools to work with students to become informed and involve themselves in the process of becoming responsible citizens in a democracy. By helping our young people to make their own decisions and to look critically at information as it is presented to them, we help to forestall deception of the public, by educating citizens who are difficult to deceive.

Our judgement is only as good as the information upon which we base decisions. The Nazi regime operated successfully because they controlled and distorted information. It is the job of educational institutions like Facing History and the Massachusetts College of Art to continually create avenues for information, for many different points of view. This beautiful and painful exhibit by the artists of Terezín enlightens us all.

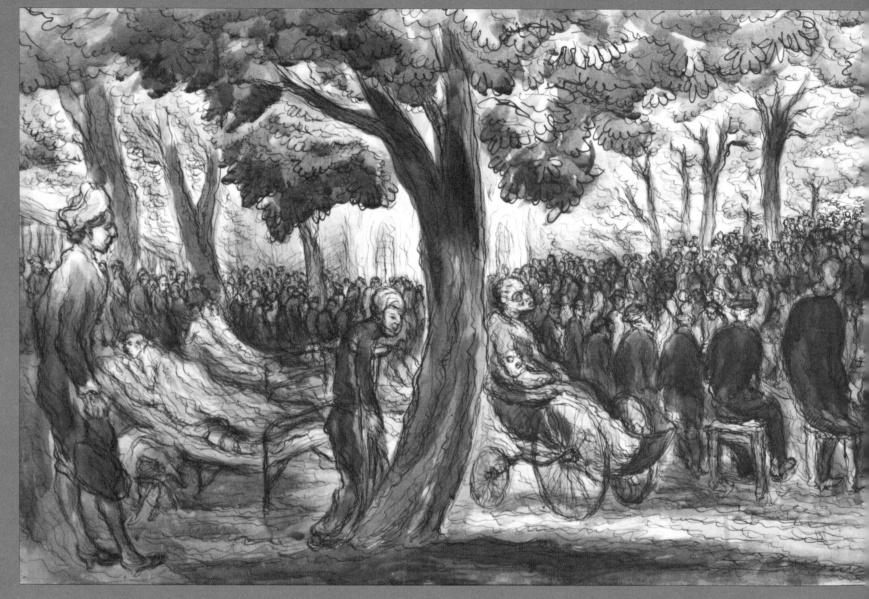

Karel Fleischmann,
Music in the Park, 1943,
pen and India ink wash,
white tempera, paper,
48 x 148 cm,
State Jewish Museum,
Prague

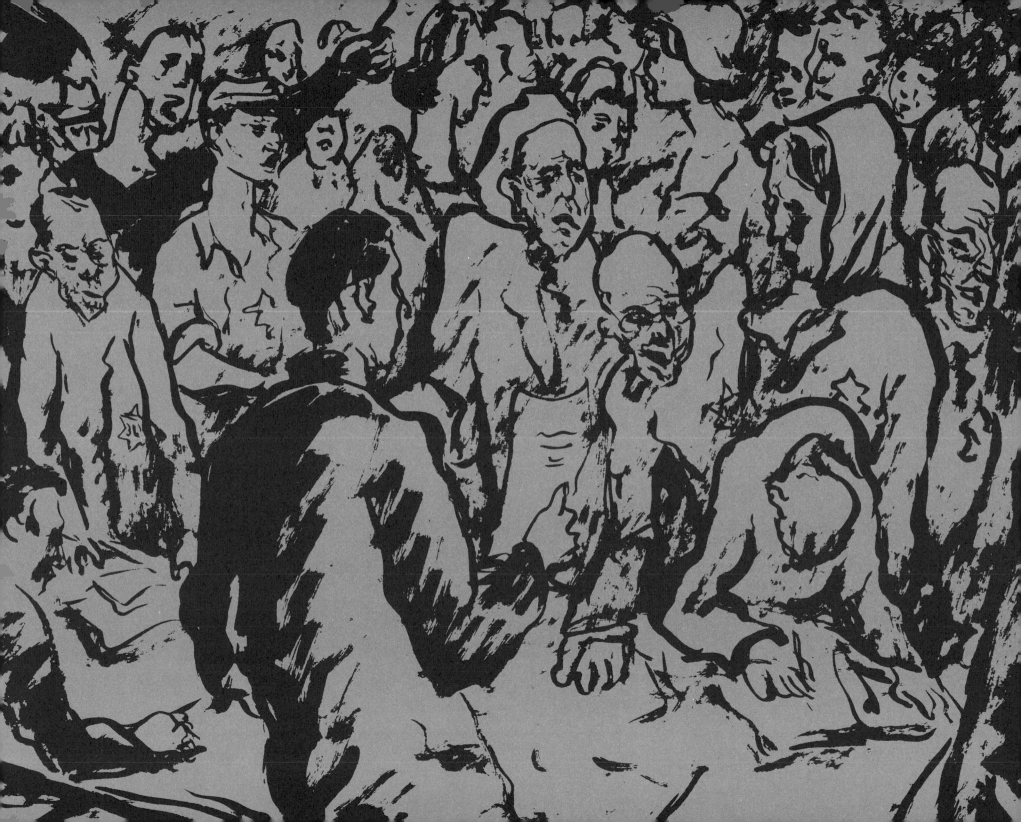

Seeing through "paradise:" artists and the Terezín concentration camp
88 pages, 21.5 cm

Published in conjunction with an exhibition at the
Massachusetts College of Art, March 6 - May 4, 1991

ISBN 0-9628905-0-2

The second printing of the catalogue was made possible, in part,
with the support of the Goethe-Institut Boston.

Exhibition History:

Massachusetts College of Art
Boston, Massachusetts
March–May, 1991

Drawing Center
New York, New York
June–August, 1991

North Dakota Museum of Art
Grand Forks, North Dakota
September–October, 1991

Jewish Community Center
Houston, Texas
November-December, 1991

University Art Museum
University of California at Berkeley
Berkeley, California
January–March, 1992

Kinsky Palace/National Gallery
Prague, Czechoslovakia
May–June, 1992

Terezín Ghetto Museum
Terezín, Czechoslovakia
September-November, 1992

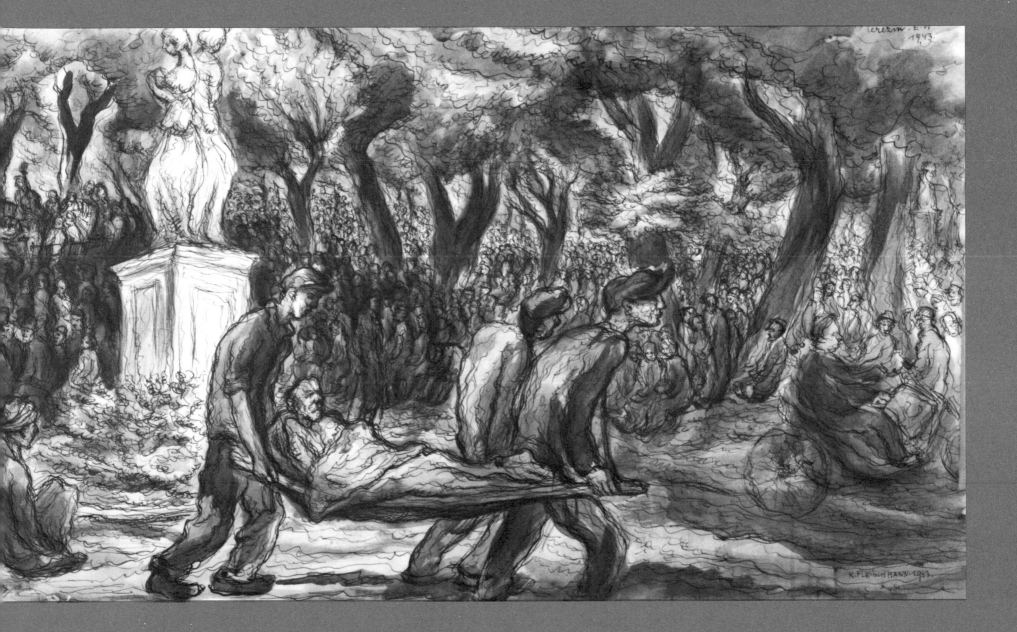

Karel Fleischmann,
View of Terezín, 1943,
brush and India ink,
paper,
50 x 99.5 cm,
State Jewish Museum,
Prague

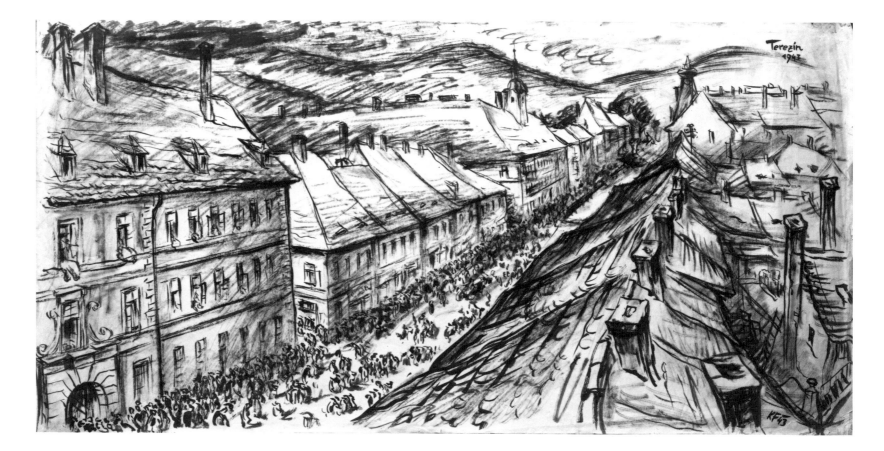

Memoir: a negligible part
Arnošt Lustig

HERE **I** STAND, AFTER FORTY-SIX YEARS, in front of L218, *Jugendheim*, a home for boys, in the former Jewish Ghetto Theresienstadt. I lived here for two years before going east to Auschwitz-Birkenau on September 28, 1944, in the late afternoon. The day I left was a lovely sunny day like today—only there are oceans of difference between then and today which make the two incomparable. Why?

In my pocket is a letter which was sent to me via the *Washington Post*, whose "Style" section ran a feature about my writing. The letter says: "Sir, I take it that you have not heard, the Holocaust, i.e. six million Jews exterminated by the Germans, is a myth, a hoax—a swindle of enormous proportions. The enclosed pamphlet should straighten out a deranged mentality about past events and the on-going anti-German hate propaganda carried on by the Jews . . . Please enjoy the pamphlet enclosed, *Six Million Swindle*."

Myth? Swindle? Hoax? In that late afternoon of 1944 I went from this greenish-colored, three-story building, then marked as L218, to the Hamburg Garrison, where fifty railroad cars stood ready to take our transport—in all, five thousand healthy young men—to the East, to Auschwitz-Birkenau—allegedly, to work. I spent almost two years in Theresienstadt—from fifteen until the age of seventeen, nearly eighteen. In the last moments that I was in Theresienstadt, I turned back to see for the last time the ghetto where I'd spent those two years with my family—mother, father and sister—not in one garrison, but close by, knowing about all of them. Now I was going away alone. I closed my eyes. But I still saw Theresienstadt in front of me. The city was part of me. It is still a part of me, as we all are hostages of everywhere we have been and of everything we have lived through.

In the midst of the second World War, the Nazi machine organized (along with other camps, prisons and ghettos) in the northern part of Bohemia, in a town about forty miles from Prague, Czechoslovakia, an unusual, strange and unique camp called Theresienstadt. It was something unheard of—something new. Why? Their intention was to create a model camp "for show" to neutral foreigners, in an attempt to deflect international criticism about the way that Germany, as a "highly civilized and cultural power," was treating Jews. While the old joke had it that 'if you beat my Jews I will beat your Jews,' the Nazis wanted it changed to "Look how we pamper our Jews in Theresienstadt, the city Adolf Hitler gave to the Jews." Really?

The Nazis spread the rumor that Theresienstadt camp was, in fact, *a Jewish paradise*—that after two thousand years of looking for a permanent home, it was, for Jews, those Luftmenschen, people of air, a normalized place of normalized people. They had a city of their own—a city Adolf Hitler gave them generously. Yet they and the Jews they sent here knew from the very start that Theresienstadt, in spite of all the facades, was merely a transit camp—a stopover on the way to the gas chambers of Treblinka, Majdanek and Auschwitz-Birkenau.

But in the letter, sent to me via the *Washington Post*, was written that "the swindle of the six million makes liars out of some respected writers." And Hitler's final solution, Endloesung, meant "emigration—not extermination." And "only a cannibal fears that a conqueror will eat him." "What the Nazis wanted," said the letter and the brochure *Six Million Swindle*, "is what every civilized country has wanted and five of them put into practice—mainly to get Jews out of their hair—all of them—to have them emigrate." Little Germany, surrounded by enemies with ten times its own population and thirty times its size, could not afford, in war time, to let such potential enemies run around free. So, the Nazis first expelled the original citizens from Theresienstadt and then transported Jews in.

But in this letter I got, even expulsion is described as a myth, because "expelling native populations was more Allied than Nazi policy . . . just as concentration camps for potential enemies were not unique with the Nazis, so the transfer of population was more a policy of the victors than the Nazis." Of course the Nazis had to expel the native populations from Theresienstadt in order to move in the Jews. To say it's a myth is possible only with the passage of time. It is a bet on human forgetfulness— a bet on human inclination to prefer to forget the bad things and to remember the good ones instead.

But the letter about the myth, swindle, and hoax was signed after the words, "Yours Truly." What to say? What to do? How to answer "Yours Truly"?

There is a timeless question: Is time the mother of truth? Of complicity? Of a lie? What is myth, lie and hoax? What is swindle? And now I am standing here and trying to go back—to recollect what was. Every house and every street is a reminder of someone, something, of the truth of my life.

Theresienstadt is not a big city. It sits on the confluence of the rivers Elbe and Ohre. It is there that I am now standing. From above this spot, the city must look like a stony star which has fallen to Earth, wreath-shaped by the central Bohemian mountains. It was first built as a fortress, but as such it never served its purpose. No enemy ever tried to conquer it; it was enough just to detour around it.

Before World War II, three and a half thousand civilians lived in Theresienstadt in two hundred and nineteen houses, along with three and a half thousand soldiers, placed in eleven garrisons. They were all removed, to the last man. Originally built to hold seven thousand people, as many as sixty thousand people were crowded into it at times. Men, women and children were separated. But—at least— they knew about each other, and were together in one place. At times it was forbidden to meet or to speak with each other. To rule the ghetto, the Nazis enlisted the help of an appointed Jewish Council of Elders. Some who served on the council were idealistic and sacrificed themselves by serving and some, partially good at one time, at other times were collaborators. Sometimes they were both. Some served willingly—some against their wills. There is a proverb which speaks of reason not prevailing if the circumstances are insane. Somebody once said that it is impossible to measure the suffering of an individual. Who then can measure the suffering of so many? Maybe, therefore, it is easier to use the words hoax, swindle, lie or myth? Sometimes it comes down to the question: What is truth? What is a lie? What is evil? What is man?

Maybe the oldest question is why do people act cruelly? What would cause people to form large concentration camps for genocide and smaller camps for transit? It's virtually inconceivable to understand why— but it was done. I saw it with my own eyes. I know it is not a myth— I was there. And now, I am here again and everything keeps pouring back.

For me, growing from a child into an adolescent and then into a man took place here. It was crowded, but we were together. Then the office of Adolf Eichmann, RSHA, in Berlin must have decided that it was dangerous for the Third Reich to leave so many people in the old fortress. Behind the Jewish question were new German experiences: the uprising in the Warsaw ghetto, the uprising of the Polish capital, the loss of occupied territory at Majdanek near Lublin with its extermination camp and huge

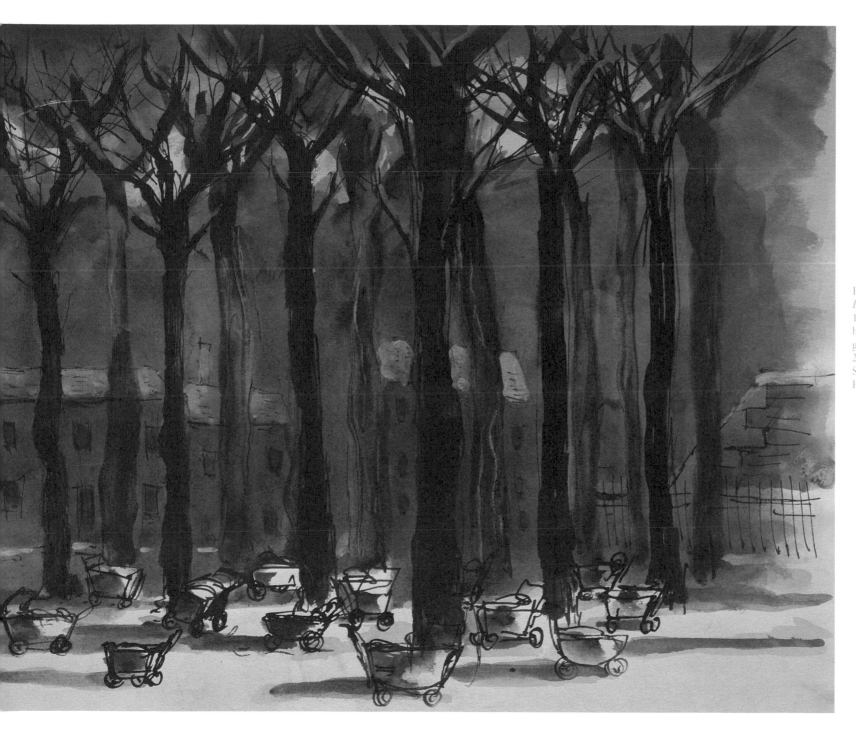

Fritta/Fritz Taussig,
Baby Carriages,
1943-4,
brush and ink wash,
gouache, paper,
24.7 x 30.6 cm,
State Jewish Museum,
Prague

13

mass graves, the liberation of the French concentration camp in Drancy. The Nazis were afraid of young Jews, so they made plans to send them to their deaths with Cyklon B in the gas chambers of Auschwitz-Birkenau and elsewhere. It had to be done immediately. A week before, Eichmann's deputy, Hauptsturmführer Moehs, and the chief of the Prague Zentralamt, the Office for Jewish Affairs, Gunther, had come to Theresienstadt. Dr. Eppstein, Judenältester from the Jewish Council, was ordered to the Nazi Commandant, where they read him the following order:

"For the rest of the war it will be necessary to use a greater amount of labor power from Theresienstadt. Experience has proved that there is a lack of space in Theresienstadt. Therefore, 5000 fully-abled working men must be sent out of Theresienstadt to meet this objective. Two thousand five hundred will leave on Tuesday, September 27th, the following 2500 on Wednesday, September 28th. Dr. Eppstein has the authority to announce these details on the public address system."

The rumor had it that we were going to Riesa, not far from Dresden, and that ours would be a labor force. Maybe because there were not enough railroad cars available, the transport could not leave on September 27th, but did leave on the 28th.

There are things one can't prove; you cannot put them on a scale. They are not measurable, such as the anxiety everybody felt before the transport. Am I going or not? Who else is going? Where? What will happen? It was like a death sentence which everybody waited for.

You can't measure that. But this doesn't make it a hoax. The invisibility makes it only intangible, but not unreal. Our hearts were like clocks, clicking towards the unknown.

But the Nazis knew. They were the first who knew it was not a hoax. They sent us for real; they shot Dr. Eppstein for real.

When we arrived at Dresden, the SS gave us postcards on which we were to write that we were at the end station and things were satisfactory, that our mothers, sisters, fathers and wives would follow us. We went from Dresden farther to the East, to Auschwitz-Birkenau. In all, 18,402 prisoners were deported during that one month. Nine-tenths of them were immediately killed upon arrival at Auschwitz-Birkenau.
The rest were left alive to do forced labor.

Myth? Hoax? Swindle? Would those, writing letters similar to the one I got, and such brochures like *Six Million Swindle*, trade their lives, their lots, their places with us?

I was one of them. I left my mother, father and sister in Theresienstadt. My father, who was fifty-two years old that September, 1944, went with the next transport. In Auschwitz-Birkenau he did not remove his glasses and went immediately from the ramp to the gas chamber, along with everyone who was ill, wore glasses, or who was under the age of fifteen, or over forty-five.

My mother left Theresienstadt during October, as did my sister.

Myth? Swindle? Hoax of enormous proportions? I only wish it were. The dead do not bear witness anymore. To write these few pages, I went back to Theresienstadt to see and to recollect, for I knew that I was to write an introduction to this catalogue in which my colleagues will speak about art, music, painting, and poetry in Theresienstadt. Only then I didn't know that I would be getting this pamphlet about the swindle and hoax and so on. So, now I feel that my portion of this work should cover what song, poetry and art tell differently. And every step, every breath, brings back what was, what happened, and what I saw and, as I said, that which can never be erased from my mind until my death. I wish that the man who wrote and sent me the pamphlet about the death of six million Jews being a swindle and a hoax could be with me, not only today, but then as well: he and all the rest who believe it never happened. I am not afraid of him; I am scared of young people who might believe him, not having heard the echo of the other voices.

Theresienstadt was and still is a strange town. We knew that from the moment we arrived there. It was a large, old fortress built in 1780 by the Hapsburg Emperor Joseph II, named for his mother Maria Theresa, and later converted into a civilian town. It remained a garrison town. Not far away was a smaller fortress used as a prison, with solitary cells, a yard for firing squads and gallows.

When I arrived here, on November 19, 1942, the first thing we were told about were the gallows. The old-timers remembered the daily order from January 10th of the same year:

"A group of inhabitants of the ghetto have been arrested in connection with the smuggling of a letter. These persons are guilty under martial law"

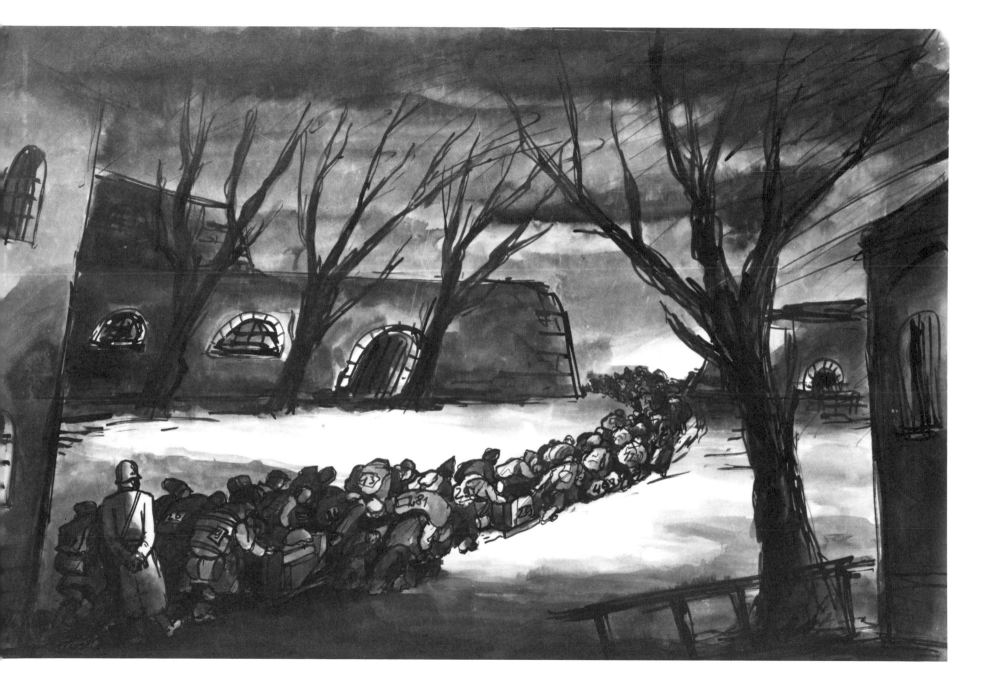

Fritta/Fritz Taussig, *Leaving Transport*, 1943-4,
brush and India ink wash, paper, 46 x 70 cm,
State Jewish Museum, Prague

Nine prisoners were hanged.

On February 26th of the same year seven more were hanged. Writing letters to family members outside of the ghetto Theresienstadt was considered a crime. It was also a crime for a husband to have a conversation with his wife who had secretly arrived at the gates of the ghetto to speak with him. Originally, the Commandant of the ghetto, Dr. Siegfried Seidl, had said that three illegal letters had been intercepted. The SS had said that if those who wrote the letters would turn themselves in the punishment would be mild. They believed him and were all hanged immediately in the courtyard of the former garrison. The Council of the Elders had to be present and were made to watch.

The shadow of those who had been punished hung over the ghetto, and the people who came before us considered it useful to let us know. For each and every transgression of the rules—even the most mild—the transgressor could count on, at the least, being included in the next transport to the East. As one of the SS, Herr Bergel, said, "The SS has a soft heart and a hard heart. Which one will be used depends on you." It did not. There were no hearts in the chests of the SS.

One camp experience that I heard about had happened after the assassination of police general Reinhard Tristan Heydrich, who was the darling and deputy of Reich Chancellor Adolf Hitler. Despite the fact that the camp inmates were isolated from events taking place in Prague, they were not isolated from feeling the impact of those sorts of things. There was a palpable shadow on June 10th, when the Commandant of the ghetto, Dr. Siegfried Seidl, ordered the readiness of thirty men with shovels and picks. They were sent to what remained of the mining village Lidice, near Prague, which had been burned to the ground. All adult men had been shot. All the women had been taken to concentration camps, and all the children had been sent either to the camps or for adoption by German families. The village was still burning. There was smoke everywhere. The entire night and all the next day the men had to dig mass graves, four yards deep. At night the only light came from the burning houses. Afterwards, they had to take off the shoes of those who had been shot and bury the corpses. All animals—sheep, horses, goats and cows—were taken to the ghetto. When I came to Theresienstadt and saw the animals, I heard the story again and never forgot it. Every sheep, every horse reminded people

where they were. Swindle? Myth? I kept seeing those animals whose original owners were now dead, in camps, or adopted by German families. I kept meeting people who came from that village burial, who were marked forever Hoax? Are these people denying even the lot of animals during the war?

At the end of July 1943 an unusual transport came to Theresienstadt. It was strange. No one was allowed to go near the windows. No one was allowed out onto the streets. Through the street an SS escort led children, dressed in rags, in the direction of the delousing station. Some children were shoeless, others limped or wore wooden clogs, the remnants of old uniforms either too big or too small. They held onto each other's hands. They were scared to death. They did not speak or smile. But in the delousing station when the SS gave orders to undress and go into the showers, the children began to cry, hugging themselves and shouting, "Gas, gas!" Nobody understood why. Myth? Hoax? Swindle?

The children were crawling with lice and dirt and it took violence to force them into the showers. The delousing lasted for twenty-six hours. Then, the children were given clean attire and were led to an isolated garrison, surrounded by barbed wire. No one in Theresienstadt was permitted to speak to them. A strict selection of fifty-three doctors and nurses was ordered to serve them. Not even the Judenältester was allowed to see them. Only one man in the delousing was able to speak briefly to one of the boys and found out that the children had come from the Bialystock ghetto, where, right in front of them, the Einsatzgruppen had shot their parents. Many children had also been shot—the group which had been brought to Theresienstadt represented only a small portion of the original number. The Bialystock ghetto, which rose up against the Nazis, was liquidated. For six days the parents fought them along with their children. Some escaped but the larger portion was shot or transported to Treblinka. Finally, the Nazis just set the entire ghetto on fire. And now, here were about one thousand five hundred children, the last of the Bialystock ghetto. Some fifty children got sick. The next day a truck came and took the sick children to the Little Fortress, not far from where we were, and killed them. Bodies were put into wooden crates and those who carried them said that the children's blood was still dripping out. Six weeks later the remaining children from Bialystock were taken to the railroad

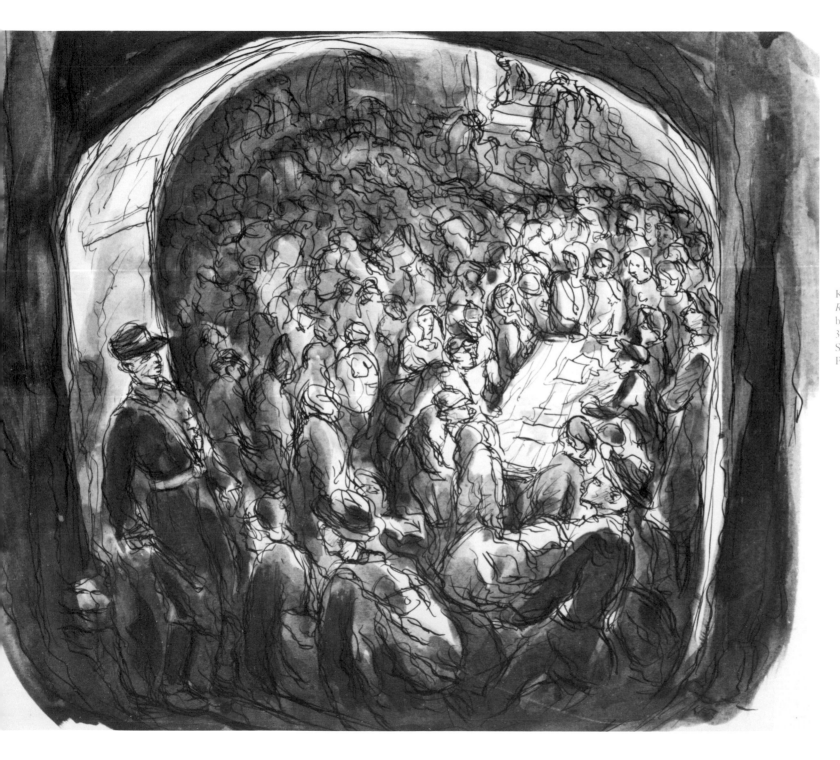

Karl Fleischmann,
Registration, 1943,
brush, ink wash, paper,
33 x 31.5 cm,
State Jewish Museum,
Prague

station along with their doctors and nurses. They were allegedly going to Switzerland. No news ever came back about them. It was only after the war that we found out that they ended up in Auschwitz-Birkenau.

But there is a postscript to this: in his trial, an SS Wisliczeny testified that the original intention of the Nazis was to exchange these children for twenty thousand German POW's and that the British were willing to let the children go to Palestine. However, the Great Mufti of Jerusalem objected to Himmler. Himmler forbade the exchange, and the children were gassed, murdered, just as were all other Jewish children in the occupied territories.

And so now here I stand, right in front of the place where the children were and from where they disappeared, like so many others. Memories flood through my mind. Would it be possible to invent such things? Could they possibly be a myth? There is no fantasy that could create what happened here and in the other camps.

Not far from here I dug the ground for a German hospital. One day the Nazis brought in a boy who, until the week before, had been in the Hitlerjugend. They had discovered that this boy's father had a Jewish grandmother, so in spite of the fact that he served in the Wehrmacht, they sent him to Theresienstadt. Over the passage of one week's time he became a Jew. It did no good for him to protest that he had nicely and bravely fought on the Eastern front for the Reich. Who was a Jew was not for him or another Jew to decide but only for the Nazi authorities. The boy refused to work and I had to work an entire day for the two of us. That was enough for me. The next day I said to him, "Now look, you are a Jew just as I am and as are all the others. You have to work with a shovel and pick or . . . " and from then on he began his strange metamorphosis. His was not the only case like that. Once it was discovered that they were of the wrong racial origin, members of the Wehrmacht were sent to Theresienstadt—even a former SS. Once a woman from Germany came in, escorted by two SS officers. All four of her sons had fallen in battle fighting for Germany. When she lost the last one she also lost her protection against being sent to the camps, and now, finally, she came here. There was also a husband whose non-Jewish wife had been killed with their child in an air raid and he had been sent here.

On November 11th, 1943, all inhabitants had to line up for general counting. First the Nazis decided to count us down to the last person. This was because from Auschwitz-Birkenau had come the complaint that out of the five thousand people sent the last time, a few were missing. What had happened to order? And the Nazi reports listed fifty-five more prisoners in Theresienstadt than there actually were.

All forty thousand prisoners had to line up in a valley where there had once been a military exercise field and on which now stood the crematorium. Eighty-year-old women and men, the sick, invalids, children and babies—everybody. On one side was the river and on the other side was the road. The hollow was surrounded by machine guns. Several times German airplanes flew overhead. Prisoners had to form groups of one hundred people each, twenty lines with five rows. It was a rainy day—foggy and windy. We began at four in the morning. There was not a quiet moment, nor any food or water. At 1 p.m. the SS began counting. They did it several times—the counting never agreed. Every moment someone died or fainted. As they tired, many people lay or sat down. Children were crying. That lasted until dusk. One woman delivered a baby. (That was forbidden and she was sent with the next transport to the East.) With the darkness and the German planes flying overhead, chaos started up among the prisoners. The rain thickened. Many believed they would be shot because of all the machine guns that ringed the area. The SS men began beating people. Now prisoners feared they would be raided from the air. The order came for them to go back. But how? Panic broke out. Nobody could see anything. Forty thousand prisoners ran as fast as they could back to the ghetto. People searched for each other in the stampede. Old women, mothers and children were trampled. That lasted until midnight. Some three hundred people remained on the rain-soaked grass until morning, dying, sick, exhausted and finally, dead.

But the count had not agreed, so it had to be repeated. And it was repeated through files. Twenty people were missing. Haindl laughed. He took out twenty cards. It was a test.

I had played a personal part in that missing-man affair which caused the counting and re-counting. I had a good friend. We had played soccer together on a youth team, on which some SS officers bet. My friend's name was Hermann Pfeffer. His mother was Jewish. His father was in the

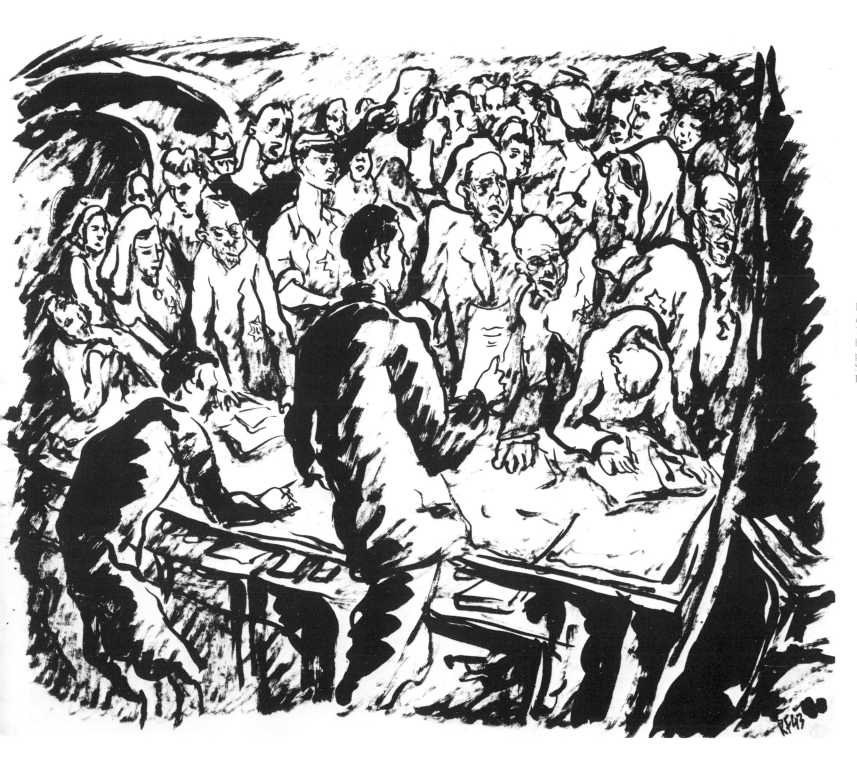

Karel Fleischmann,
*Registration for
Transport*, 1943,
brush, ink wash,
paper, 64 x 70 cm,
State Jewish Museum,
Prague

SS. One day he disappeared from the ghetto. Later I got a postcard: Prague is not what it was. He had to sell his coat, his jacket, everything. There was nowhere to go—everybody was scared to hide a Jewish boy because if caught it meant certain death. Finally he sold his shoes to buy a railroad ticket back to Theresienstadt and was caught. They put him into a bunker and arrested me. Haindl asked me if I'd known of my friend's attempt to escape. I said I did not. It was dark in the bunker and I was scared. I thought I'd seen my last moment in life. They discovered that my friend had remained listed in the ghetto evidence as if he had not escaped. So, they ordered the counting. And I was put on a transport.

The Nazis promised that they would not separate families. But in September of 1943 I was sent to the transport with my sister but without my mother or father. In this particular transport, the Nazis intended to free the ghetto of many people. So, they included some prominent residents as well, including the Secretary of the French Navy, German generals, barons of industry and the like. They lined up a group of about forty waiting for the Commandant. I joined the very end of the group with my sister. When the commandant came, the rest of the transport was already in its place in the cars. "What does it mean?" asked the Commandant, and the Lagerältester answered "Sir, they are the prominents and they expect an audience with you." The Commandant looked at them with disgust. To humiliate them he walked to the opposite end, so now my sister and I, the last ones in the group, stood in front of him. "What do you want?" he asked me. And I, dressed in my transport outfit for the harsh winter in the East, said to him, "Sir, I am in this transport, in spite of the fact that my father remains here working for the war industry." What I meant to say was that he was *kriegsbeschaedigt*, wounded in the war. But being nervous, I made a mistake and said *kriegsbeschaeftigt*, employed in the war production. "Take him out of the transport," the Commandant ordered the Elders, but I did not move. "My sister is also in the transport," I said, and my sister stepped forward. "Take her out too. And that's it." Away the prominents went to the East and my life and my sister's life were, at least for the moment, saved. I later heard that no one survived from that transport.

With the War advancing the Nazis tried even harder to convince the world that their treatment of Jews was not so bad. The International

Commission arrived on June 23, 1944, at 11 a.m. Its members were Frantz Hvass, Director of the Political Department of the Danish State Department, Dr. Eigil Juel Henningson, Chairman of the Danish Red Cross, and Dr. Rossel, representative of the International Red Cross in Berlin. They were escorted by an entourage of the SS headed by Sturmbannführer Rolf Gunther, Eichmann's deputy.

Invalids, the sick, old people, badly dressed people were forbidden to appear on any of the streets through which the Commission had to walk.

The commission visited prominent residents: opera singer Henriette Beck, whose husband was the director of theaters in Bonn and Munich, and who had engaged the second wife of the Nazi Luftwaffe Reichs Marshal Hermann Göring; Dr. Luian Dauber, who defended the first Nazis in early trials; Ella Gerriets, whose brother-in-law was a Gauleiter in Pommern. They also visited some former war heroes who were protected from the transports. They spoke to Baroness von Bleichrodern, granddaughter of Baron Gerson von Bleichrodern, economic advisor to Kaiser Wilhelm II. All in all, they visited eighty-one prominents. Among them were some German generals including one field marshal. There were also a few politicians—including the Secretary of Justice in Prague, Mr. Meisner. Then the Committee left.

The Nazis invited the film crew of the Aktualita to come to Theresienstadt and to make a film about the nice life the Jews were leading: "Der Führer schenkt den Juden eine Stadt".

For the Red Cross visit, even the SS Scharführer Rudolph Haindl was nice to the children for the benefit of the camera; according to rumors, he was a member of one of the murderous groups of the Austrian Chancellor Dollfuss, and had kicked an old woman to death for collecting stinging nettles to cook them. He was tried and hanged after the war. Even he posed for the camera, smiling, and not insisting that he be greeted by Jews from a distance of three steps, as he had demanded just the day before. The town was improved for the purpose of filming and also for the visit by the Danish Red Cross—a request that had been supported by the Swedish government. Jewish women even had to brush the pavement with their hair brushes to help get things ready. The city square, where once there had been only military parades, was transformed into a garden with a musical stage. The city temporarily took on the appearance of a seaside

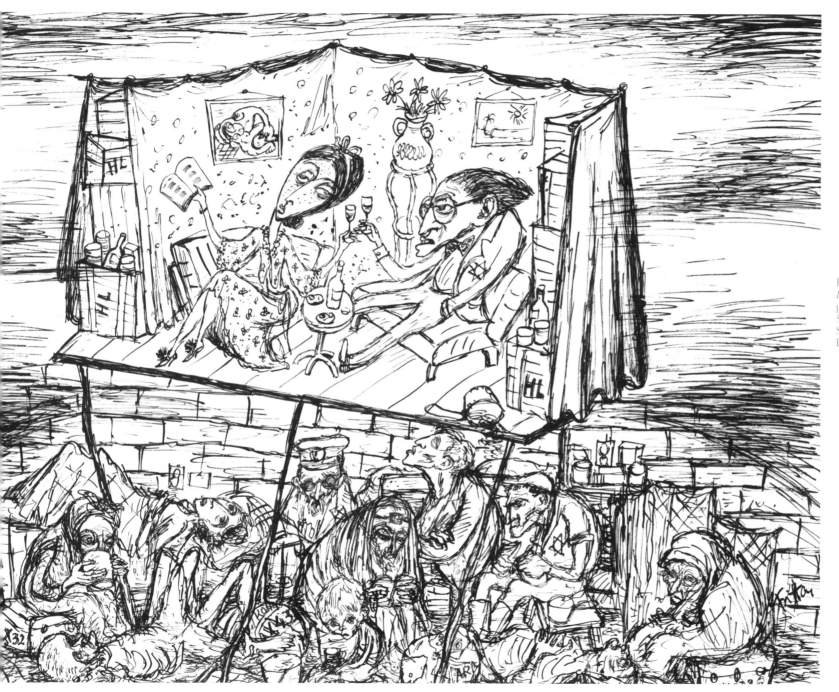

Fritta/Fritz Taussig,
Life of Prominent, 1943-4,
pen and ink, paper,
57 x 74 cm,
State Jewish Museum,
Prague

resort. Stores were filled with relatively nice things (not, of course, actually for sale—such things were forbidden to prisoners). For a few days there was even a bank that looked like a real bank. The apartments of prominent prisoners were furnished with new furniture. So that nothing would be spoiled the Nazis sent their own people as spies to mingle with Jews on the street, disguised as Jews, complete with yellow stars. Kitchens were painted. All types of cultural events were permitted: opera, concerts and operettas such as *Die Fledermaus* were performed. Schools got new equipment, and because everyone knew that schools and teaching had been strictly forbidden to Jews for all those years, the Nazis allowed signs to be put on the doors of schools stating that schools were "temporarily closed for vacations." Nurses were given white uniforms. One SS officer even had to vacate his villa so that it could temporarily become the "Home for Children." Throughout the fortress were signs: "To the coffeehouse— To the Spa—To the dining room"— and so on. Only the most handsome men and women were permitted to walk the streets.

For the film, Kurt Gerron, a German film star, was given the job of making us laugh. His films were known—*The Blue Angel* by Joseph von Sternberg with Marlene Dietrich. Our home for boys, among others, was ordered to congregate at the courtyard of the largest of the garrisons. Above us hung the cameras of the UFA and Aktualita. Gerron, directing the show, stood in the middle, at the highest bulwark, sandwiched between two SS men, and started telling jokes. We promised ourselves not to move our lips, not even to think of laughing. Gerron tried hard. Nothing. His face was flushed with anxiety. Both of the SS officers started to be nervous. Eventually, one of them said something to Gerron. But we were ready not to laugh.

Suddenly Gerron, standing high under the heavens, started laughing, long and hard. It was strange. Looking at him and listening to him made you laugh in spite of yourself. We resisted—and we tried to resist more, but we had to give in. In a minute, three thousand men and women, young and old, sad or indifferent, began to laugh for no apparent reason, for the sake of the Nazi cameras, for the sake of Nazi propaganda. For Gerron proved to be a first class actor—he was able to do what was expected of him. Finally his face was happy. Cameras started to roll. Jews were smiling at their fate in the Theresienstadt ghetto. Maybe Gerron felt

as he never had before—that he had met and fulfilled his greatest and most challenging role in the arena of both life and film. (Afterwards, his reward was to be sent with the next day's transport—and to end up by dying in the gas chambers of Auschwitz-Birkenau, directly off the ramp, like so many others.) The Nazis were able to produce a hoax. The reality was different. The filming went on.

Today I know that everybody who survived did so because the Nazis killed someone else instead. The furnaces had to get their daily portion— ten thousand people by day and ten thousand by night in Auschwitz-Birkenau. I saw that with my own eyes, too, because I was sent there from Theresienstadt with the next transport, without my family, but, eventually, they all went, too.

It's like a circle. Myth? Hoax? Swindle? As a fortress, Theresienstadt was built into the ground, surrounded by thick walls. There was never enough light in those buildings. There was never enough fresh air. What space there was was most often used for storage. It was a paradise for rats and mice. As SS General Reinhard Heydrich said in October 1941, "Jews can build their habitations deep under the ground."

Here I am standing in Theresienstadt and the scenery is the same. Times are different, though. I feel free, but only on the outside. Inwardly I am still a prisoner because it is impossible to forget, and just as impossible to communicate what happened here. Only the six million dead would be able to tell, but the dead cannot speak—only the living, and for us, tired and dying out, it becomes harder and harder to speak out. To speak about the camps is so difficult that the best among us who spoke out are dying by their own hand. The latest was the Italian writer Primo Levi. Before him were Paul Celan, Jean Amery, Tadeusz Borowski.

The myth? The hoax? Swindle? It would seem that people of the caliber of Primo Levi and these others kill themselves because they feel their inability to express even a shred of what happened, while the people for whom everything that happened seems to be a trick, a myth, a hoax are talking louder and louder. The witnesses to the truth are getting older and weaker and their voices are fading, so it seems that the lie is taking over the truth.

But history is truthful. Time is the mother of truth. And I am standing here, reflecting on some things I saw with my own eyes and heard

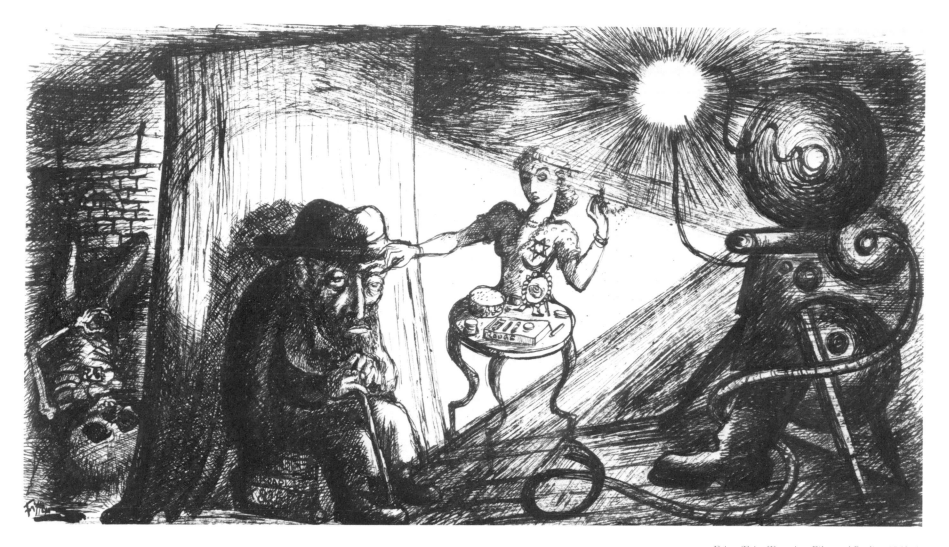

Fritta/Fritz Taussig, *Film and Reality*, 1943-4,
pen and ink, paper, 32 x 57 cm,
State Jewish Museum, Prague

with my own ears. I still bear the scars. The visible and the invisible ones. I feel them still. I hate to prove them—to anyone.

I am grateful for this exhibition in Boston, Massachusetts, in the United States of America, the last country of truth and hope, the land of patience and the ability to do what is right. To the people who undertook the task of bringing this exhibition alive, I can only express my thanks. This exhibition, the individual and collective effort of many people from many places near and far, is timely, and, I hope, is the best answer to those who sent me that letter with those strange—very strange—words: hoax and myth, trick, swindle.

Theresienstadt was the truth. When people are dead and their testimony, maybe, mute, there is art. It is the only witness for many civilizations—many catastrophes gone by. So it is in this case, too.

Wouldn't it mean killing the dead people for the second time? Stealing from them—after denying them graves—also the dignity of death? The finality of death?

To the writer of that letter and to all those like him, this exhibition will prove no hoax, no swindle of six million, no myth. There is the immortal testimony of wit, personifying people, events, time. The truth is irreversible.

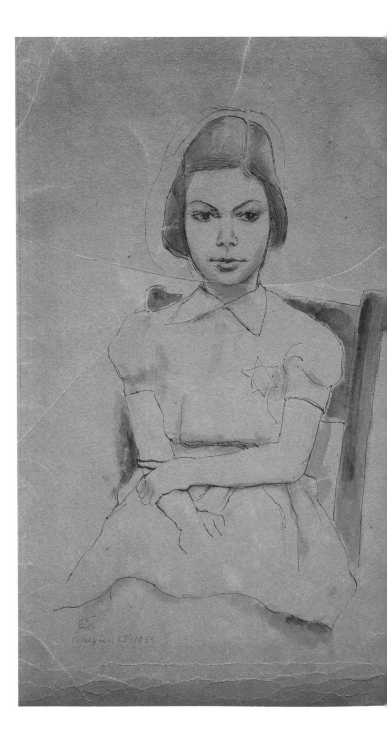

Staying alive in Terezín
Marjorie Hellerstein

Leo Haas,
Girl with Star, 1943,
pen and ink wash, paper,
42 x 25 cm,
State Jewish Museum,
Prague

TEREZIN—CALLED THERESIENSTADT IN GERMAN—was a ghetto town, established by the Nazis in November, 1941, in what was originally a fortress town sixty-three kilometers (about forty miles) from Prague. In the fall of 1941, two groups of young men arrived to make the town ready for the Jews who were to be sent there from various parts of Czechoslovakia. They were called *Aufbaukommando* and consisted of workers, craftsmen and specialists in construction, but since the town had been stripped of any comfortable living accommodations and materials to work with, the *Aufbaukommando* could do little to make it livable.

By December of 1942, a camp administration had been established, and there were 7,350 Jews in the unfurnished barracks. The camp administration was headed by an Elder, two Deputies, and an advisory Council of Elders. They took care of the organization of the ghetto/camp—its health, work details, water resources, food distribution, record keeping, technical repair and eventually, its leisure time activities. All the orders for work had to come from the SS Commander in charge of the ghetto. The orders, rules, and regulations changed constantly. It was forbidden to leave the barracks after the evening roll-call, to smoke or own matches or lighters, sometimes to walk on the pavements or sometimes to walk on the roads and the central square, to address German officials or policemen except officially, to send letters out of the camp. All infringements of these rules were severely punished, the culprits sent to the Little Fortress (a nearby prison fortress), beaten and sometimes executed. In February, 1942, sixteen men were hanged for communicating with the outside world. Eventually some postal services were established and allowed to function, as it pleased the Nazi officials.

The reasons for the establishment of this ghetto/camp changed over the years of its existence. First it was meant to be a temporary camp for Jews from the Protectorate (Bohemia and Moravia) until they could be sent to Poland or to certain conquered territories of the Soviet Union. At the same time it was considered as a possible source of labor, as the Jewish leadership hoped would happen. Then it was envisioned by Heydrich and Eichmann as a temporary ghetto for old people, particularly for those prominent in Germany and Austria. Finally it was used, in 1944, as a "show" camp, for a visit by the International Red Cross.

Erratic rules, constant changes of sleeping arrangements, meager and often moldy and spoiled food rations, queueing for hours for food or for laundry and repairs, bad sanitary facilities, lice and bedbugs—all contributed to the oppressive atmosphere governing the lives of the inhabitants. But worst of all was the fear of being transported. From January, 1942, until October, 1944, with some interruptions, there were sixty-three transports, totaling 86,934 people. The transports were known to be headed "to the East" and to what most people wanted to believe were worse but survivable conditions. Most of the transports were sent to Oswiecim (Auschwitz) and about 5% of those transported survived.

Was it self-deception? Was it wishful thinking? Or was it the only way to wait out the horror? Everyone knew that being arrested and taken to the Little Fortress probably meant death. Since there were more than a hundred deaths every day in the ghetto itself, from disease and malnutrition, death was a part of the everyday life. Death was not remote or unexpected; it was in the next bunk or on the road or in the "hospital" with no medical supplies. But it was impossible for most people to believe in calculated mass extermination. Leo Baeck, the highly respected German rabbi and scholar who survived Terezín, was told in 1943 about the gassings in Auschwitz. He did not tell anyone. "Living in the expectation of death by gassing," he said later, "would only be the harder."

Life in Terezín was hard from the first moment of arrival. The arriving prisoners had to walk two miles from the train station to the town carrying their luggage, no matter how old or feeble they were. They were put into unheated, extremely crowded rooms and had to sleep on the ground or on straw until beds became available "through transport or death," as Dr. Edith Kramer-Freund reports. She was at first put into an attic room with three hundred women, until she began to work as a doctor; her social status improved and she was put into a room on the ground floor with seven women. Nothing was supplied; she had to buy a blanket from another inmate for half a loaf of bread. It was also possible to "buy" clothing in the clothing store, where the belongings of people who had died or been transported were kept. All purchases were made with ghetto currency— the Moses crown, introduced in May, 1943. The women physicians also had the privilege of cleaning the rooms and office of Eichmann, who occasionally visited the camp.

In spite of the mental and physical degradation, most people went on with their lives. Hope was sustained by the cultural activities which the inmates organized, and by some hidden radio receivers, which eventually informed them of the defeats the Nazis were more and more experiencing. Information from scraps of precious newspapers and from friendly Czech guards was quickly spread.

As part of the perversity with which they governed this world they had created, the Nazis forbade suicide and punished the relatives of anyone who tried to or succeeded in killing himself. And yet the Nazis never intended the Jews of Terezín or of any other ghetto or camp to survive the war. In fact, as the war went more and more against them, they seemed to find it more imperative to finish their destruction. Gassings were sped up in the death camps, prisoners from some camps were sent on death marches to other camps in freezing weather, and the inmates of Terezín were sent on transports to the East in large numbers in the fall of 1944. On the other hand, the Nazis may have felt that some evidence of their humanity might be necessary in the eyes of the victorious world if they lost the war. Terezín, which had been represented to some inmates (particularly the old and prominent from Germany, Austria, and Holland) as a "model" ghetto, might still serve some purpose for Nazi self-preservation. The dilemma was not resolved. For the last year of the war— from May, 1944, until April, 1945—the officials at Terezín alternated between elimination of the populace by transports and "embellishment" of the premises for showplace viewing.

On November 11, 1943, one of the cruelest of the perverse acts against the inmates of Terezín took place. A general census was taken, not by counting bodies in the barracks or by counting the personal cards in the files, but by marching everyone (except the bedridden, mothers with babies, and prisoners) to a large field a couple of miles from the camp. From 9:30 a.m. until about 10:00 p.m., everyone had to stand in the same place, without bathroom facilities, with only the food they might have had the foresight to bring. There were several miscounts; finally at 10:00 p.m. the rumor spread that they were returning (it isn't clear that the officials announced it), and the people began to walk back in the dark along a narrow path through a single opening in the ghetto walls. Several hundred old and sick people died because of the exposure. The census was finally

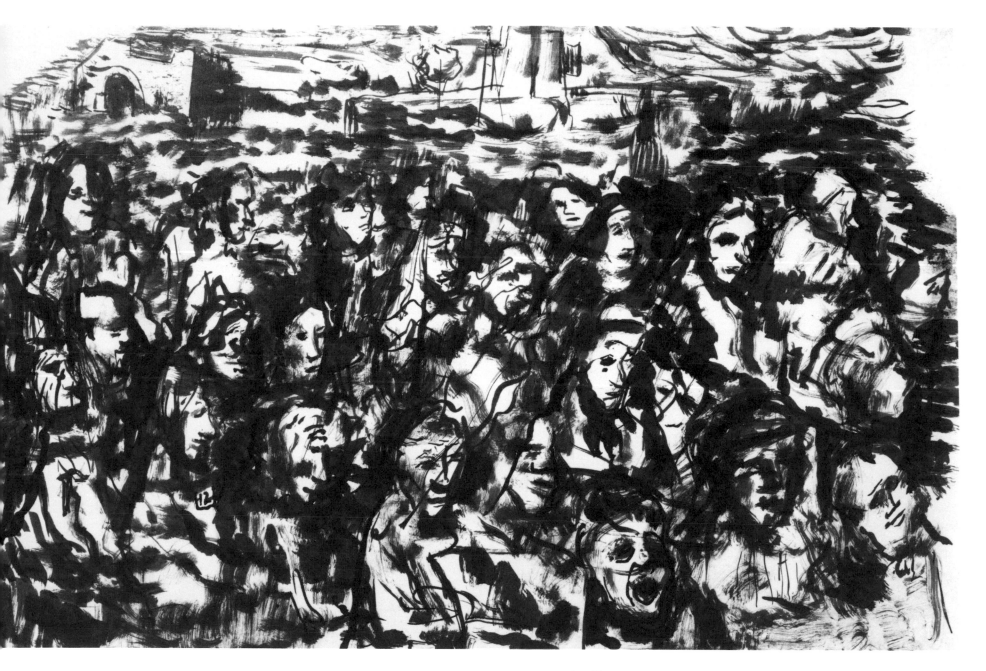

Otto Ungar,
Numbering in the valley of Bohušovicé, 1943-4,
brush and ink, paper, 42 x 61 cm,
Terezín Monument, Terezín

made by the use of personal documents, and then transports were renewed; in December about 5000 people were shipped out.

After this thinning out of the population, the beautification of the ghetto (or the "embellishment" as it is sometimes called) began. The originating reason was the demand by the International Red Cross at the instigation of the Danish Red Cross that the camp be inspected. In October, 1943, about 456 Danish Jews were sent to Terezín. Though both the Danish and Swedish people had tried to hide Jews, some were caught by the Nazis. Immediately after they arrived at the camp, the Danish and Swedish Red Cross demanded that they be allowed to see the living conditions. At that stage of the war, the Germans evidently felt that it would be politic to agree. They began to clean and polish the ghetto, under the direction of a new commandant, Karl Rahm. (A June, 1943, visit by the German Red Cross and its negative report seem to have produced little change.)

More population adjustments occurred. In January, 1944, a large group of Dutch Jews arrived; in May, 1944, before the arrival of the Red Cross Commission, 7500 prisoners were transported to Auschwitz. The ghetto was thereby reduced in size from its impossibly overcrowded state, and later, in what the Commission was allowed to see, it was reduced even more. Only the first floor rooms of the barracks buildings along the route traveled by the Commission were cleaned and furnished and reduced in inhabitants; the upper floors were jammed with the excess residents.

What could be seen or was allowed to be seen was beautified. The town square was covered with turf and flower beds and sand paths. A pavilion for an orchestra was built in a corner of the square; an infants' playground with swings and a pool was created, and a playing field with showers and dressing rooms was made. All the buildings along the selected route were painted; rooms on the first floors were refurbished; a former Sports Hall was transformed into a community center with a hall for concerts, a stage, and a library. Flowers were planted everywhere.

In particular, the living quarters of the Danish prisoners were enlarged and refurnished, as it was assumed that these would be most closely monitored. The rooms of the senior officials of the Jewish administration were also refurbished. And so, when the Commission arrived (consisting of the Commissioner of the International Red Cross, a representative of the Danish foreign office, representatives of the Danish Red Cross, the Commissioner of the German Red Cross, and various German heads of Departments in the Protectorate), they were escorted along a carefully programmed route by Paul Eppstein, the head of the Council of Elders, and by SS officers, past girls working in the fields and singing, past bakers in white gloves loading loaves of bread onto carts, and into the community center, where a performance of Verdi's *Requiem* was in progress on one floor and the children's opera *Brundibar* was being performed in another part of the center.

One witness and participant in these proceedings, Frederick Terna, a young Czech Jew interned from 1943 until the fall of 1944 and part of the crew of one of the Hunderdschaft (roving repair and maintenance groups), says that the general reaction to these activities was that it was all a stage play in which the Commission members were willing actors. They must, he says, have made some kind of deal with the Nazis in which they would be willingly deceived and led through the settings arranged by the officials without asking questions or departing from the established route, for some concessions they thought were important. The prisoners had tried to make the clean-up work so good, Terna says, the painting so meticulous, that it could only have been suspicious. The Commission did not voice its suspicions.

The Red Cross report, available through the International headquarters in Switzerland, confirms the suspicions that the members of the Commission (at least their spokesman, Dr. M. Rossel) saw only what the SS officers chose to show them and believed everything they were told. Living arrangements are "attractive" and "airy", though perhaps somewhat overcrowded; medical supplies were in a "state of plenty"; the Jews are free to administer themselves "as they see fit"; and this place was an "Endlager", that is, "normally once admitted to the Ghetto no one leaves." Almost every aspect of the camp was seen to be "satisfactory," and they were "astonished . . .that it (was) so difficult to obtain permission to visit Theresienstadt."

The Nazis were convinced that their elaborate charade had worked. Did they believe that this would affect world opinion then or later, when they would have to bargain for good peace terms? Did they so enjoy the manipulation of lives and opinions that it hardly mattered what use

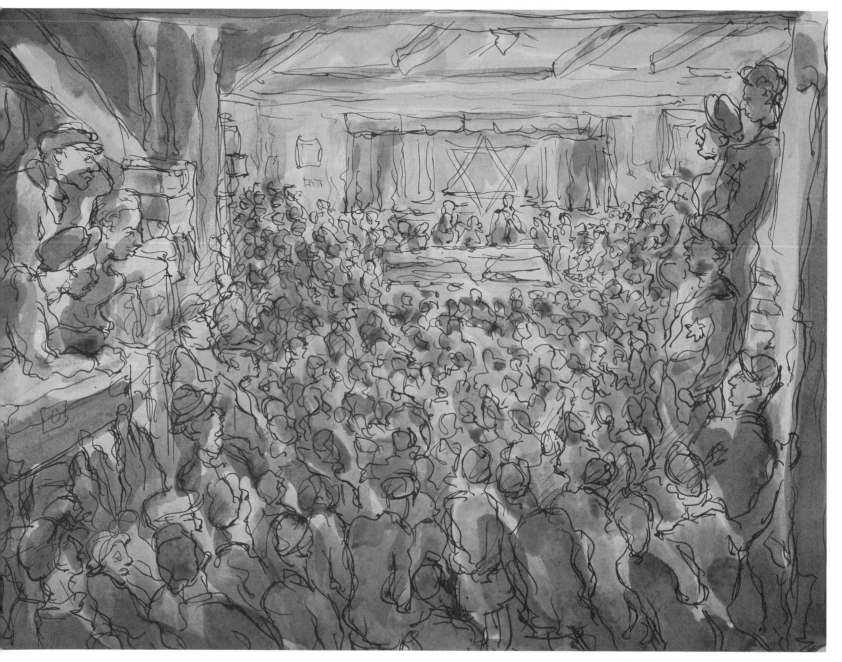

Karel Fleischmann, *Cultural Lecture*, 1943,
colored pen and India ink wash, paper,
25.3 x 30.5 cm,
State Jewish Museum, Prague

was made of this visit by the Commission? Whatever the reason, the Nazis decided to record on film the illusion of reality that they had created. They started filming in August, 1944, under the direction of Kurt Gerron, a well-known German cabaret performer and theatrical producer, who was also an inmate. They added scenes of a music hall performance on an improvised stage in a field, of the prisoners at a bathing beach on the banks of the river Ohre, and of a happy family sitting around a supper table. The commentary was spoken by a German "trustee" for Czech films. The film was edited and completed in March, 1945. So far as is known, it was never shown publicly. In October, 1944, most of the participants and performers were transported to Auschwitz.

Again, the reason for making the film is not quite clear. Was it, as one commentator said, intended as anti-Semitic propaganda, to show how well the Jews were living in contrast to the destruction in the rest of Europe and the Reich? Or, on the other hand, was it intended to counteract reports about how badly the Jews were treated, for the "information" of neutral countries then and for after the war? Since paradoxical reasoning characterized the thought processes of the Nazis running the camp, it is possible both lines of reasoning were used.

The same paradoxical reasoning may have produced the relaxation of rules that allowed the cultural life in Terezín to grow and flourish from 1942 until almost the end of the camp's existence in May, 1945. The German officials gave their consent to set up a Cultural Department (or, an Administration of Free Time Activities), and hidden activities became openly pursued. Music, art, lectures, poetry writing and reading, play and opera productions and cabarets were constantly being made and performed. Overtly, the poems, art works, productions of musical works (such as, *The Bartered Bride, The Marriage of Figaro, The Magic Flute*, and an evening of Czech music) were conventional and non-controversial. But there were original art works, poetry, and musical works which were implied comments on their situation and on the totalitarian regime which controlled them. *The Emperor of Atlantis (or, Death Abdicates)*, written by Petr Kien, poet and painter, and composed by Victor Ullmann, composer and musician, included within it in a minor key the Nazi anthem *Deutschland über Alles*, and Martin Luther's chorale *A Mighty Fortress is our God*. With those thematic undertones and with its subject of Death, the opera is clearly a political allegory.

Rabbi Leo Baeck (who was sixty-nine when he arrived and who lived through the experience and after the war until age eighty-three) organized seminars and lectures, which were made known to the inmates by word of mouth and started with small groups of people. Later lectures were very well attended. One lecture given by Leo Baeck in June, 1944, has survived and clearly demonstrates the significant implications of the intellectual life that he was encouraging. The subject of the lecture seems to be abstract and remote from the reality of the inmates' physical and emotional situation and their narrow prospects for survival, but it is meant to counteract the inevitable despair of their circumstances. The lecture was called "The Writing of History," and discusses, first, a number of important historians from world history: Herodotus, Thucydides, Polybus, Tacitus, Caesar, and briefly the prophets of Israel, Dante, and some nineteenth century historians. Then he makes his point:

> A people becomes certain of its history when it comprehends its idea, when its own spirit, part of the spirit of mankind, is alive within it. Through this a people lives truthfully, just as an individual lives truthfully through this A people dies when its spirit, its task , has died within it A people can be reborn. After losing itself it can find itself again And that, too, is the greatest thing that can happen to a people, to defend and represent the cause of mankind in its cause, to fight for itself and in doing so to fight for humanity at the same time.

He condemns the silence of historians about "historical crime for which justification has been sought in expediency and success." If the Nazis had listened (happily, for his survival, they didn't) they would have heard their acts properly labeled.

The memoirs and poems written in Terezín were not exhibited or made widely known in the camp, especially if they expressed some of the horrors of the living conditions or were too precise about their sufferings. But several excellent poems written at Terezín were preserved and later published, and many wonderful poems were written after the liberation, particularly by Ilse Blumenthal-Weiss. Here is an example of one:

> *Self-Portrait*
> With death as my shawl
> I wander behind footprints
> and the echo of
> Years ago. Years ago.
> Stand on ocean shore of tears
> and ignite the memorial candle.

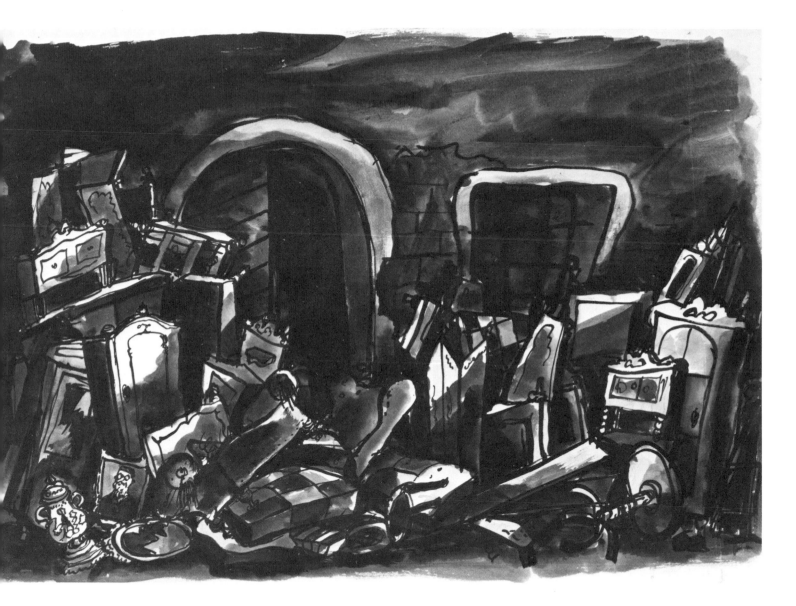

Fritta/Fritz Taussig,
Furniture Storage, 1943-4,
brush, India ink wash, paper,
42 x 59 cm,
State Jewish Museum, Prague

31

"There was in Theresienstadt," says Frederick Terna, the survivor who is now an artist and is living in New York City, "a spirit of looking ahead . . . We felt a sense of moral superiority . . .and (an) immense intellectual activity."

Terna, who spent about one and one half years in Terezín before being sent to Auschwitz and then to Kaufering, became an artist at the camp. Arriving as a young man, not yet twenty, he got his education from his father (also at Terezín) and from the rich assortment of lectures, concerts, seminars, as well as from the precepts of artists such as Fritta/Fritz Taussig, Leo Haas, and František Zelenka, who were available during any leisure moments. He was exposed to ideas about history and to intellectual speculation about the future. Within the deprived and depraved conditions of the ghetto, he did not find despair or defeatism. Notwithstanding the effects of severe malnutrition on memory and energy, some of the best minds of European culture continued to function as long as they remained alive. Only in the last stages of their lives were some people reduced to the condition of "zombies" (or "Mussulmänner", as they were called in the death camps.)

Terna became a protegé of architect/artist František Zelenka, and from him and other artists at Terezín learned to improvise art materials, such as pieces of dowels rubbed in india ink for drawing. The established artists who were sent to Terezín worked in the studios, producing the graphs and charts and posters that the Germans needed. They had access to art materials and were thus able to create, secretly, the works of art that were hidden and that survived the war.

The artists' energy and inspiration to create seems to have come from the same center of consciousness, the same need to retain consciousness and imagination, that drove the professors, cultured businessmen, rabbis, and readers and thinkers—all herded together in Terezín—to organize the intellectual activities. The same consciousness and imagination compelled the composers and musicians to compose on scraps of paper and to play, at first, on improvised instruments.

Netty Vanderpol, a Dutch survivor also now living in the United States, became an artist of needlepoint many years after her experiences in the ghetto/camp. She has conflicting memories: of humiliating and frightening experiences but of a strong sense of stability from the presence of her family, with whom she was able to share quarters. She has never forgotten their spirit: her grandmother got dressed up with white gloves to go to her work detail of cleaning the latrines; her mother lay in Netty's bed to warm it while Netty was working; her father (labeled "a prominent") kept their spirits up, used opportunities to make their lives more comfortable, and finally made the decision to join a trainload of Terezín inhabitants who were actually sent to Switzerland and freed in January, 1945. He meticulously documented significant events in the ghetto, particularly the deportations "to the East."

She knows that members of her family paid a terrible psychological price for their experiences, and she has used the metaphor of her art to express that psychological destruction. She also knows that her art is her chance to transcend her experiences, to convert them, to affirm her creative nature. She values her ability to make art and her discovery of that ability. Thinking of herself as an artist, she does not look only to her experiences in the camp as a source of inspiration. Those experiences were part of her life but they are not all of her life.

Helga Weissová Hošková was a talented twelve year old, who was told by her father to "draw what you see." It was the best possible advice for a young artist, forcing her to look, to watch for details, to compose her vision. She was, by such honesty of observation, saved from the escapism of glamorized memories and dreams, and she was encouraged to exercise her skills with care and attention. With her father, she created a little book, as a present for her mother on her mother's birthday. Her father wrote the satiric story and Helga illustrated it with miniature vignettes of the places and people in Terezín.

Helga kept a diary and recorded in it, in remarkably mature and direct statements, her personal experiences and those significant community events she observed. The sickness and death of her friends, her own sickness (probably typhoid fever) and "lucky" recovery, her anguish at the sight of the "misery and suffering" of the old people and their transport out of the camp, bullied and beaten by the "Gestapo"—through all this she did not hide her eyes nor did she pity herself. She was an observer of one of the most mysterious and painful incidents in the history of the ghetto— the arrival and sequestration of about 1200 starved and diseased Jewish children from Poland. These children were cleaned up, cured, and shipped off again, this time, as was later discovered, to Auschwitz and death. She saw with amazement the beautification of the ghetto for the visit of the Red Cross Commission and was reminded, she doesn't know why, of the fairy tale "Table, set yourself!"

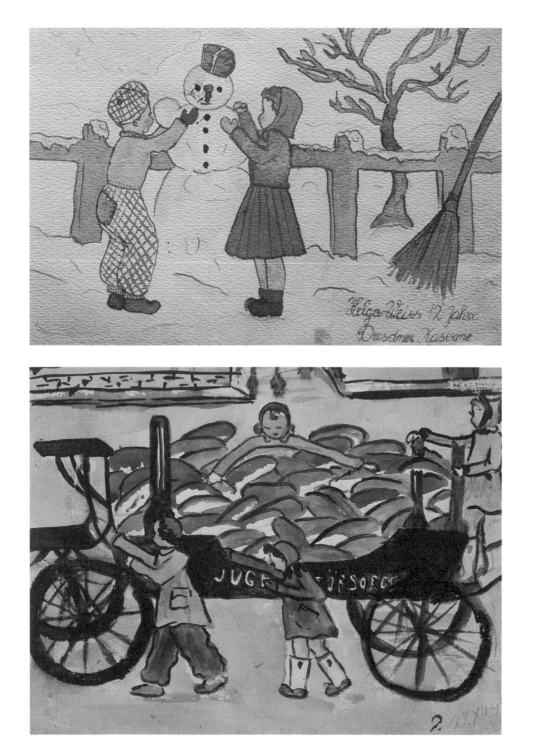

Helga Weissová Hošková, (at age of twelve)
Snowman (first drawing in Terezin), 1942,
pen, ink and watercolor, paper, 13.5 x 21 cm,
private collection

Helga Weissová Hošková,
Cart/Hearse with Bread for Children, 1942,
watercolor, paper, 16.5 x 19.8 cm,
private collection

Helga and her mother survived, and after the war returned to their old apartment in Prague. Helga went to art school, married a musician, and is still living in Prague actively producing prints and paintings, inspired by her memories but also by her absorption in whatever experiences she has since had, such as in Israel, as a result of a fellowship she won, and in contemporary Czechoslovakia.

The day-to-day strength these three young people gained from the presence of their families cannot be measured. Their families are an integral element in their memories of Terezín and the nourishment for whatever growth they achieved during those crucial years. The family was the core of their community. Other relationships were necessarily new, tenuous, tentative. This "community" lasted through most or all of their stay in the ghetto, though finally Terna's father was transported and did not survive, and Helga's father was also transported and did not survive. Netty and most of her immediate family came through together. Within each family there was warmth and trust. The only other source of trust and community in that arbitrary and threatening atmosphere came from the activities initiated by the Jews themselves—the music, art, lectures, theater. If artistic activity can take place in a dangerous environment, it becomes extraordinarily important.

The end of Terezín reflected the chaotic purposes of its existence. April, 1945, was a month of hope and terror. At the beginning of April, Paul Dunant of the International Red Cross visited and was treated to a another display of the spruced-up village. He left without comment. About a week later, a Swedish bus arrived to take the Danish Jews home. The Camp Commandant Karl Rahm watched their departure politely, probably with his own future in mind. A week or so after that departure, trainloads of Jews from other camps were dumped onto Terezín—emaciated, dying, and infested with typhus. The typhus produced an epidemic in the camp, which claimed the lives of doctors, nurses, and many susceptible residents, especially in the deteriorating sanitary conditions in the camp. On May 3 the International Red Cross returned and took over the camp. In a few days the Russians arrived and took over the medical work and the provisioning of the camp. By August, 1945, everyone had left Terezín, in one way or another.

Bibliography

Baker, Leonard. *Days of Sorrow and Pain: Leo Baeck and the Berlin Jews.* Oxford University Press: New York, 1978.

Baeck, Leo. "The Writing of History," in The Synagogue Review, *Journal of the Reform Synagogues of Great Britain*, November, 1962. An address at the Terezín concentration camp, found in one of Leo Baeck's books: "An academic address, given on 15 June, 1944, at the Community House, Theresienstadt."

Bondy, Ruth. *Elder of the Jews: Jakob Edelstein of Theresienstadt.* Translated by Evelyn Abel. Grove Press: New York, 1981-89.

Conditions in Theresienstadt, According to a Danish Report. From the American Legation, Stockholm, Sweden, October 18, 1944. Sent to the Secretary of State, Washington, D.C.

Dawidowicz, Lucy S. *A Holocaust Reader.* Behrman House, Inc.: New York, 1976.

Fischmann, Zdenka E. "Music in Terezín, 1941-1945," *Cross Currents 6*, 1987.

Jacobson, Dr. Jacob. *Terezín, the Daily Life,* 1943-45. In *Jewish Survivors Report, Documents of Nazi Guilt.* Jewish Central Information Office, London. In Leo Baeck Institute Archives, New York.

Karas, Joza. *Music in Terezín, 1941-1945.* Beaufort Books, in association with Pendragon Press: New York, 1985.

Kramer-Freund, Dr. Edith. *Journey to Freedom.* in Leo Baeck Archives: New York. (Translated from Tribune, Frankfurt, 1985).
As a Doctor in Theresienstadt. in Leo Baeck Archives: New York.
Hell and Rebirth. in Leo Baeck Archives: New York.

Lederer, Zdenek. *Terezín.* London: F. Goldston, 1953.

Mannheimer, Max E. *Theresienstadt* and *From Theresienstadt to Auschwitz.* In *Jewish Survivors Report, Documents of Nazi Guilt.* Jewish Central Information Office: London. In Leo Baeck Institute Archives: New York.

Schwertfeger, Ruth. *Women of Theresienstadt: Voices from a Concentration Camp.* Berg Publishers Limited: Oxford, New York, Hamburg, 1989.

Spiritual Resistance: Art from Concentration Camps. Union of American Hebrew Congregations: New York, 1981.

Terezín. Pro památník Terezín. 1988. Terezín. Published by the Council of Jewish Communities in the Czech Lands: Prague, 1965.

The Theresienstadt Ghetto. Confidential report by Dr. M. Rossel, Delegate of the I.C.R.C., translated from the French and submitted to Roswell J. McClelland, representative of the War Refugee Board, and then sent to John W. Pehle, Executive Director, War Refugee Board, Washington, D.C. on October 26, 1944. In the archives of the American Joint Distribution Committee, Inc., New York.

Interviews with the following survivors:
Helga Weissová Hošková; Frederick Terna; Netty Vanderpol

35

Fritta/Fritz Taussig,
Moving of Sudeten Barracks, 1943-4,
pen and India ink, cardboard, 69.5 x 96.4 cm,
State Jewish Museum, Prague

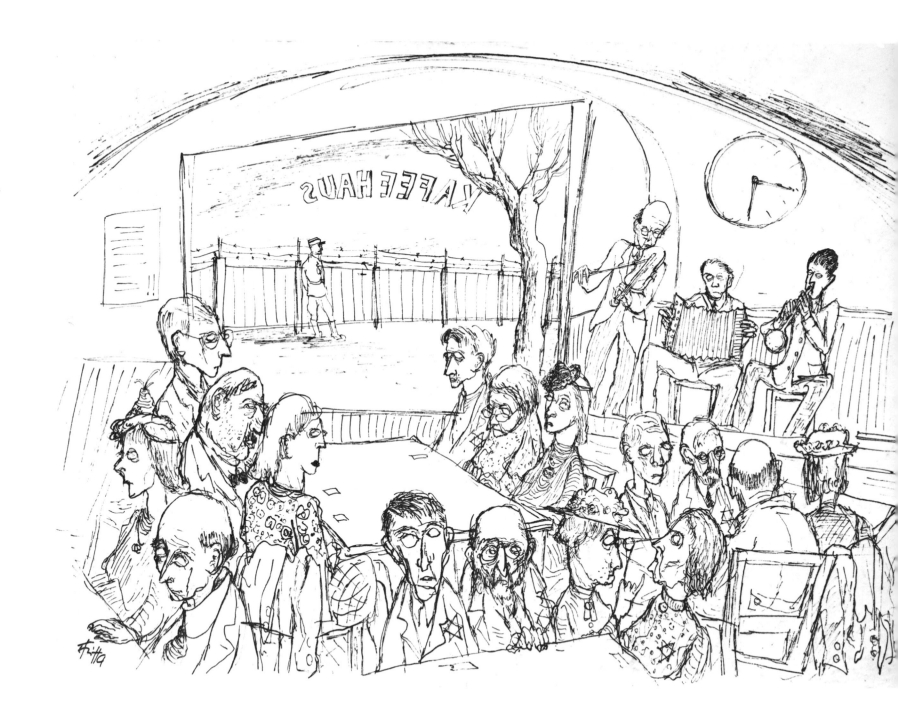

Seeing through "paradise"
art and propaganda in Terezín

Johanna Branson

left:
Fritta/Fritz Taussig, *Kaffeehaus*, 1943-4,
pen and ink, paper, 44 x 60 cm,
State Jewish Museum, Prague

below:
Joseph E. A. Spier,
Kaffeehaus, from *Bilder aus Theresienstadt*, 1944,
print, watercolor, paper,
17 x 23.2 cm,
State Jewish Museum, Prague

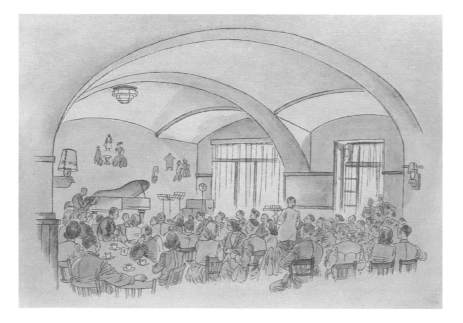

TEREZIN PROVIDES US with a rare opportunity to study the power of images. Artists were at the center of camp activities, working both as prison laborers, producing the range of images the SS Camp Commanders wanted, and as private individuals, making the kind of images they themselves wished to make. The artists at Terezín were engaged in a struggle with their SS captors over what could be permitted to be seen, over what artists could lead viewers to imagine. It is clear both the SS and the artists believed that if they could control what people were able to imagine was the truth, they could have a profound effect on how these same viewers would act on the real.[1] An astonishingly wide range of images was produced in Terezín, from which very different kinds of information may be secured.

Consider the following pair of images. The first is a drawing entitled "Kaffeehaus," one of 18 views included in a booklet called *Bilder aus Theresienstadt* (Pictures from Terezín), made by the Dutch artist Joseph Spier. In this watercolor, we see a room full of people seated at tables, being served coffee by white-jacketed waiters. They are listening to a pianist, who is seated at a grand piano on a stage at the far end of the room, in front of a wall decorated with small mural paintings. We cannot see individual people very clearly, but taken as a whole, it is a colorful, convivial scene. This picture may be compared with a black and white drawing of the same coffeehouse by the Czech artist Fritta/Fritz Taussig. In this view, people are seated at tables on which there is no coffee, only tickets of entrance. There are no waiters. There is a three-person combo playing at the right side of the drawing; in the rear center is depicted a window, through which we see a single guard stationed in front of a large wooden barricade almost immediately outside the window. We can't see past this barricade; it seals off our view. The people in the coffeehouse can be seen more clearly in this drawing than in Spier's. Their faces are haggard and sad, and each seems turned inward, lost in private reflection, not engaged at all in the kind of social conviviality present in the first drawing. Where the ambience of Spier's drawing is one of a general crowd of people engaged in urbane relaxation and entertainment, Fritta depicts a scene of confined and isolated individuals.

1. I am grateful to the writings of Catherine Clement for this formulation of the relationship between the imagined and the real.

If we look at a second drawing by Fritta, we see this same barricade from the other side. Here a vast, empty, white space looms in the foreground; we are put in the position of inhabiting that space, looking towards the barricade. The space on the other side of the fence is nearly black. We see the tops of a row of tall buildings pressed up close to the fence. Squeezed between the buildings and the white boards we can just make out row after row of heads. A second drawing by Spier spells out what we are looking at. He also depicts a space divided by a fence, this time diagonally from upper right to lower left. On the right we see an extremely crowded street of people with hunched shoulders, all walking one way. On the left, we see one upright SS officer striding down an empty street. All survivors' accounts of Terezín mention that the parks of the city were off-limits to prisoners and that special "Aryan Ways" were marked by fences, so that the crowds of the ghetto were kept strictly separated from the paths of the commandants. The coffeehouse was in a row of buildings bordering the city square; when looking out the window while listening to music at the coffeehouse, prisoners would in fact not have seen the lawns and trees of the park, but a high barricade of boards.

Still a third drawing by Spier, however, "Im Stadtzentrum," also from the book *Bilder aus Theresienstadt*, shows the facade of the coffeehouse from the outside, and in the street there is an open boulevard, with a few strolling, well-dressed people, and shop windows full of elegant clothing. It becomes clear that this book presents one coherent view of the camp, a view which is completely contradicted by survivor accounts, and even by some others of Spier's own drawings.

In fact, in both the work of Spier and Fritta we encounter one of the central, unique realities of Terezín art. We have drawings by both men which are completely contradictory. That is, the work done as prison labor presents utterly different information than the work each did privately, after hours. We, as viewers, have the unusual opportunity to look at conflicting works done by the same person, often of the same subject, and to raise for ourselves questions about how we secure information from visual images— about how, in short, we know what to believe.

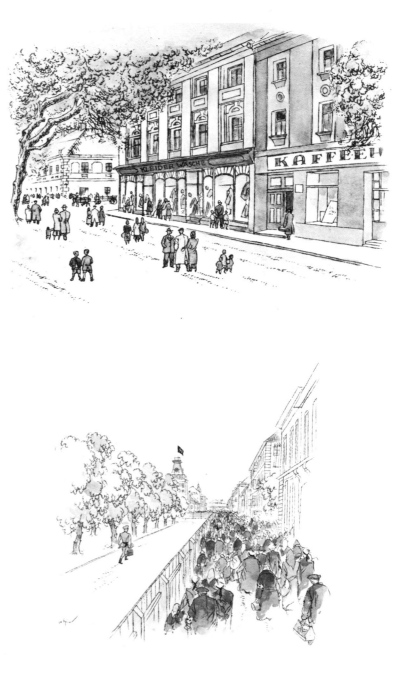

Top:
Joseph E. A. Spier, *Im Stadtzentrum*, 1943, watercolor on paper, 22 x 17.3 cm, Leo Baeck Institute, New York

Bottom:
Joseph E. A. Spier, *Aryan Way*, 1943, watercolor on paper, 22 x 17 cm, Leo Baeck Institute, New York

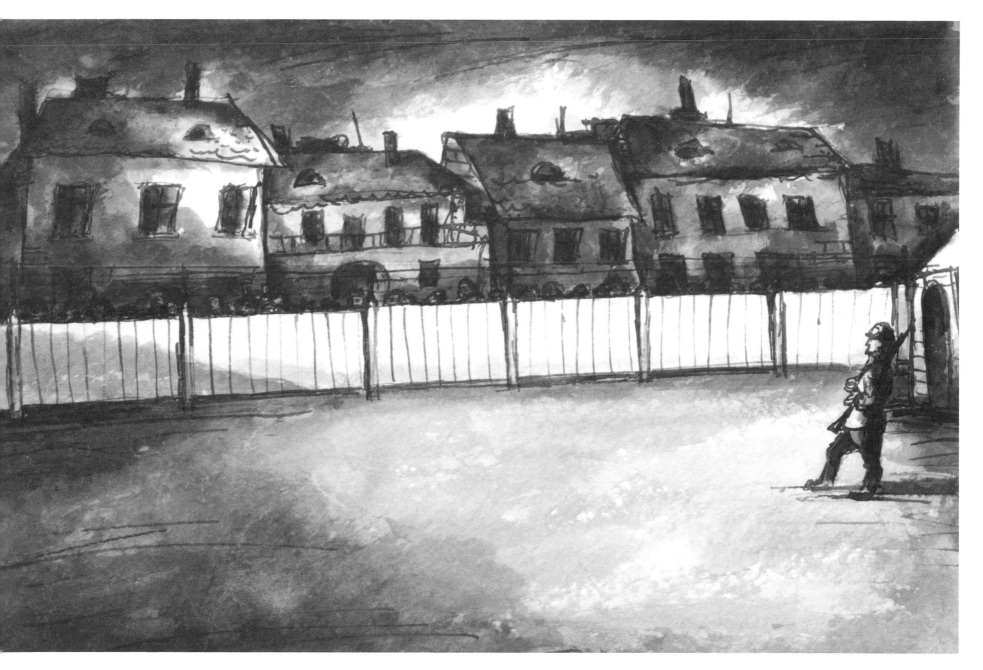

Fritta/Fritz Taussig,
Border of the Ghetto, 1943–4,
brush, India ink wash, paper, 39 x 57 cm,
State Jewish Museum, Prague

Both Spier and Fritta did artwork as prison laborers, each as the leader of two separate studios. Fritta was with the first transport of planners and designers sent to Terezín in late 1941 to prepare the town to become a concentration camp-ghetto. He became the head of the *Technische Abteilung* (Technical Drafting Studio) for the camp. This studio performed a wide range of functions, from preparing illustrated reports on the progress and efficiency of the ghetto as a work camp, to designing maps, hearses and latrines (page 62). Fritta's work may be easily recognized in the illustrations for bureaucratic reports; he drew dramatic scenes of the building of the railroad track to Terezín, the improvement of the water system, and the building of new barracks (page 47). He also pilfered materials from the studio and, working covertly, executed a large number of powerful drawings of camp conditions which completely contradict the illustrations in the bureaucratic reports. He was one of the group of artists arrested in the summer of 1944, after the Red Cross visit, accused of producing "horror propaganda," and imprisoned, tortured, and transported to Auschwitz, where he died.[2]

Spier was a leader in another kind of studio, the so-called Lautscher Werkstätte, named after a decorative arts studio in Prague.[3] Artists in this second studio made a wide range of artworks, almost all for the SS to use for personal decoration of their homes, or to sell outside the camp. These artists made copies of artworks admired by the Nazis (one man spent all his time copying the paintings of Spitzweg, an 19th century artist), decorating the lodgings of the SS, painting boxes, making lampshades. Joseph Spier, for example, decorated the walls of the SS clubhouse;[4] Hilda Zadiková, a Czech artist trained in Germany, did many flower paintings, and was sometimes asked to fabricate coats-of-arms for SS officers who had decided to become noble in origin. As was true of the artists working in the Technical Drafting Studio, the Lautscher Werkstätte artists often made very different work covertly. Zadiková, for example, made drawings depicting hunger and exhaustion at Terezín. She was able to save

fragments of them, and carried them in a pouch hung around her neck and hidden inside her dress.[5]

The two studios were thus responsible for producing different kinds of objects. The Technical Drafting Studio made most of the images that would represent the camp to the outside world, more specifically to the Nazi command responsible for overseeing the productivity of the camp. They also did representations of the organizational ideas of the SS for the camp itself, making visible in maps and charts the goals and values of the bureaucracy. The Lautscher Werkstätte, on the other hand, made decorative, domestic objects either for the SS commanders of the camp to use personally or to sell outside the camp. In both cases, a coherent, uniform vision of the camp was depicted; it was portrayed as a productive, organized community of Jews working and relaxing in carefully alternating blocks of controlled time. Individuals are never depicted; a generalized atmosphere of well-being is sustained in the manufactured vision produced by both studios.

In these depictions, the SS organized the existence of a middle European town into categories which they thought needed to be addressed, commonly-held views of normalcy which they thought needed to be met. There are "the spacious town park," "the puppet show for children," "the bands of singing agricultural workers," "the adults relaxing in the coffeehouse," and so on. To put it simply, the images produced by both studios were stereotypes. That is, although the artworks seem to have been taken from a mold, the mold itself is in no single instance a true depiction of an existing reality. These views present a simulation of a cheerful, colorful, spacious, prosperous Jewish ghetto in Nazi-occupied Europe of the early 1940's. The function of the stereotype in this context seems to have been to keep the level of reflection generalized, withholding specific information which might provoke viewers to raise questions. The SS chose these kinds of images because they fulfilled the need to reassure visitors from the outside that nothing unusual was happening in the

2. An account of this treatment of the artists was published after the war by Leo Haas, the only surviving member of the group. See "The Affair of the Artists of Terezín," Terezín, published by the Council of Jewish Communities in the Czech lands, Prague, 1965, pages 156-161, and pages 63-68 of this catalogue.

3. Marianne Zadiková May, the daughter of Hilda Zadiková, had generously shared with me much information about this workshop and its activities. Mrs. May was 19 years old when she was imprisoned with her parents in Terezín.

4. This is recounted in Jacob Jacobson, "Terezín: The Daily Life, 1943-1945." *Jewish Survivor's Report*, Documents of Nazi Guilt #6, Jewish Central Information Office, London.

5. Zadiková later combined these scenes into a *Terezín Calendar*. The Hebrew writing on the drawings was contributed by Leo Baeck.

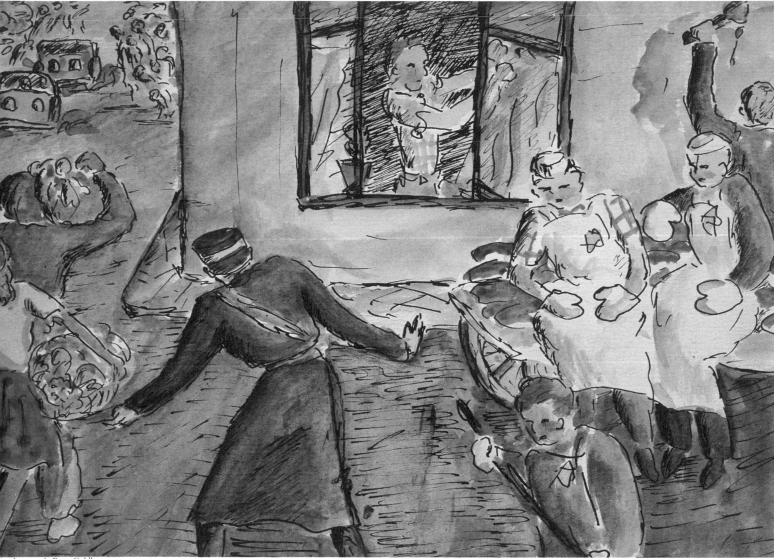

Helga Weissová
Hošková,
*Beautification for the Visit
of the Red Cross
Commission*, 1944,
ink and watercolor, paper,
15.2 x 21.7 cm,
A Living Memorial to the
Holocaust—
Museum of Jewish
Heritage

41

concentration camps of the Reich. All was unremarkable, and therefore no specific action need be taken.

The circumstances surrounding the production of the book mentioned earlier, *Bilder aus Theresienstadt*, are very instructive about the high hopes the Nazis had for the power of images to help them accomplish their goals. As is well documented in histories of the camp, until the Fall of 1943, the SS commanders of Terezín had much more concern for how their own superiors would view their work than for how people outside the Reich would view their activities. Most of the artists' work, accordingly, was aimed towards making the camp look productive and efficient in illustrated reports sent to Berlin. This lack of concern apparently extended even to a Red Cross visit (by members of the German Red Cross) in the Spring of 1943 to inspect camp conditions; no special preparations seem to have been made for this visit. The report of this delegation was negative, its members having found conditions to be very bad.[6]

In September of 1943, however, this attitude towards outside opinion began to change, most markedly when a transport of over 400 Danish Jews arrived. The Danes were fiercely protective of their Jewish citizens, and had managed to help most of them escape to Sweden. They constantly bombarded the Terezín commanders with demands for reports about the welfare of Danes in the camp; they sent parcels of food, medicines, and supplies, and they asked that a Red Cross visit be conducted to inspect the camp, insisting that the delegation be international, including Danish members.[7] Consequently, during the spring of 1944, a "beautification" campaign occurred, in which a specific route was planned for the delegation to follow. In a surreal display of stagecraft, buildings were whitewashed,

streets were cleaned, flowers were planted, a kindergarten was built, and so on. On June 23, the visit occurred. The reports filed by both the Danish and the Swiss members of the delegation were extremely favorable; compared to the rest of wartime Europe, Terezín was very nearly a spa.[8]

At the actual visit, a copy of the book made by Joseph Spier under SS orders, *Bilder aus Theresienstadt*, was attached to the report filed by the Swiss member of the delegation, Dr. Rossel.[9] It is interesting that the report of the Swiss delegate is constructed in categories which often correspond to content in the drawings. For example, he finds food adequate; there are drawings of a clean, amply-stocked bakery and butcher's shop. He finds the streets open and full of well-dressed inhabitants; there is the aforementioned illustration of a street with blossoming trees and well-dressed shoppers in front of an elegant clothing store and the Kaffeehaus.

The reaction of the prisoners to the Red Cross visit was mixed. One post-war report says the Danish prisoners were very reassured by the visit, and by the messages of strong support sent by their King.[10] The famous Berlin rabbi and Terezín leader Leo Baeck, however, recorded in his postwar memoir of the camp that the prisoners were "devastated" at the success of the Nazis in convincing the delegation that the Camp was a humane, healthy, vital community.[11] To be fair to the Danish delegate Hvass, it is often reported that he knew very well he was being deceived. He was afraid a negative report would result in retributions against the prisoners, and so he filed a positive one, not knowing that there could have been no worse retribution against the prisoners than the transports to the East already occurring.

6. This is recounted in a letter dated October 26, 1944, from Roswell McClelland, the War Refugee Board Representative in Switzerland to the Executive Director of that organization in Washington, DC.

7. This is recounted in many survivors' accounts, as well as in books published by Danish authors after the war. See, for one example, *The Rescue of the Danish Jews: Moral Courage Under Stress*, Leo Goldberger, editor. New York University Press, New York and London, 1987.

8. I am aware of two reports filed by members of the Red Cross Delegation which visited the camp. The first is "Conditions in Theresienstadt, According to a Danish Report," October 13, 1944, prepared by Otto Leyvsohn and Kai Simonsen, on a meeting of the Danish legation in Stockholm on July 19, 1944. The second is "The Theresienstadt Ghetto," a report of the June 23, 1944, visit by Dr. M. Rossel, Swiss delegate of the International Red Cross. Both of these reports exist in English in the archives of the American Jewish Joint Distribution Center, New York.

9. The International Red Cross in Geneva has a copy of Spier's book, which was included with Rossel's report. I am familiar with four such booklets of scenes of Terezín. Three are in the State Jewish Museum in Prague: besides the one by Spier, there are books made by Hilda Zadiková and by Malvina Schalková. The fourth is in the Terezín Memorial archives; it was done jointly by Fritta, Kien, Haas, and other members of the *Technische Abteilung*. The story most often told about these booklets is that the SS ordered several to be made so they could choose the one they thought most appropriate to give to the Red Cross delegation as "documentation" of conditions in Terezín. Arno Parík, Curator of the State Jewish Museum, has found no documentation to either support or dismiss this story of a kind of propaganda competition.

10. *The Rescue of the Danish Jews*, op. cit.

11. Quoted in Leonard Baker, *Days of Sorrow and Pain: Leo Baeck and the Berlin Jews*. New York and Toronto: Oxford University Press, 1978.

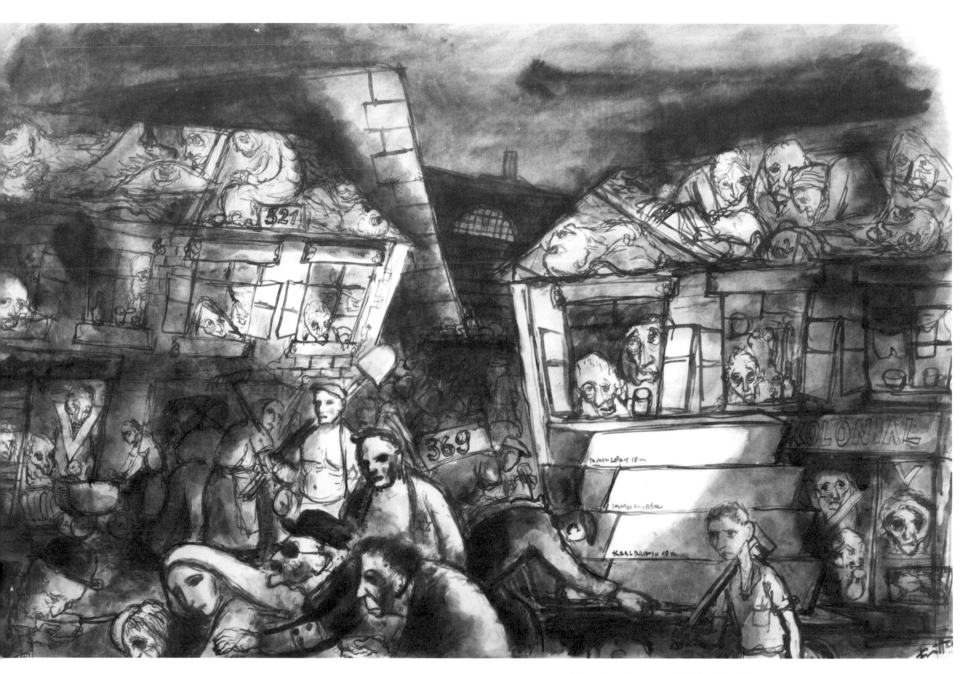

Fritta/Fritz Taussig, *Life in Terezín*, 1943-4,
pen and ink, paper, 55 x 84 cm,
State Jewish Museum, Prague

At least two artists made private drawings of the preparations the SS made to deceive the members of the Red Cross delegation. One was a young girl, Helga Weissová. She was in Terezín with her mother and father for nearly three years, when she was 12 to 14 years old. She had always been very interested in art, and her parents had taken care to pack her drawing materials when they were sent to Terezín. She was too old to participate in the art classes conducted by Friedl Dicker-Brandeisová, but she drew on her own, making dozens of drawings of daily life in the camp. She was never questioned by the SS; she thinks she was ignored because she looked even younger than her age, and so, as a child, she did not arouse any suspicion. She openly drew the transports of prisoners being shipped to "the East," scenes of hungry people searching through potato peels for something extra to eat, as well as domestic scenes of women battling against vermin by checking for lice and bedbugs. She also drew two pictures of the preparations for the Red Cross visit. The first depicts people sawing off the top layer of a triple-deck bunk. The Red Cross delegates were only permitted to see double-deck bunks. The second depicts a scene of people busily whitewashing housefronts, hanging curtains, bringing in pots of flowers; in the upper left, one can see the automobiles carrying the Red Cross delegation approaching (page 41).

The second artist to portray the "beautification" was Fritta. In his drawings he had long exposed as fraud the SS portrayal of Terezín as an old age home, or as a "good" productive Jewish ghetto. One drawing is usually referred to as "Potemkin Village". False fronts of shops are propped over piles of corpses. A pair of lovers in one corner embrace under a window in which a death's head peers out. In another corner, the characteristic, bare-branched tree of Terezín is surrounded by black crows. In a second drawing (page 23), a haggard old man sits in front of another facade, again screening a pile of corpses. He is being attended to by a make-up artist whose lower body is a table holding cosmetics. Off to the right, a surreal, animated film camera prepares to record the old gentlemen.

Fritta's drawing refers to a second major strategy of visual deception the SS embarked upon, shortly after the success of the Red Cross visit. They apparently decided to take advantage of the "beautified" parts of the town to make a film, entitled *Der Führer schenkt den Juden eine Stadt*

(The Führer Gives a City to the Jews). This film was directed by the prisoner Kurt Gerron, a well-known German film actor and cabaret star. Slightly under twenty minutes of the completed film have survived; quite a bit more existed, which we can reconstruct partly from drawings done by artist Joseph Spier, who, at the request of the camp elder Eppstein, documented what the film crews were shooting. It is, even today, a convincingly normal-looking film, done in the standard "documentary" style, with seemingly candid scenes accompanied by music and a voice-over. We know from survivors' accounts that every single scene was meticulously staged and cast with prisoners who fit the SS notion of what a Jew should look like while not evidencing malnutrition or disease. The same set of images was presented as was orchestrated for the Red Cross delegation— the viewer sees various scenes of work, the bunkhouses (two bunks high), the bath-house, a soccer match, a performance of the children's opera *Brundibar*, and a performance of Verdi's *Requiem*. We know that most of the people who were filmed, as well as director Gerron, were sent to Auschwitz once the shooting for the film was finished, in a new series of transports occurring in October, 1944. It is virtually certain that this film, although produced in a release print, was rarely if ever screened in its entirety, and so it never achieved the same powerful effect as the "beautification" campaign for the Red Cross visit, with its attendant visual propaganda.

In *MEIN KAMPF*, Adolf Hitler argued that propaganda was a means, not an end. He said that it could be looked at only from the principles proper to it, "Then the most cruel weapons were humane if they conditioned the quicker victory . . . The task of propaganda lies in directing the masses towards certain facts, events, necessities, etc., the purpose being to move their importance into the masses' field of vision." And later in the same text, he states, "Recognition in its passive form corresponds to the majority of humankind, which is inert and cowardly . . . Propaganda, therefore, needs not to rack its brain about the importance of each individual it enlightens, about his ability, achievements, and understanding or of his character. . ."[12] Hitler thus presents viewers as inert, cowardly—

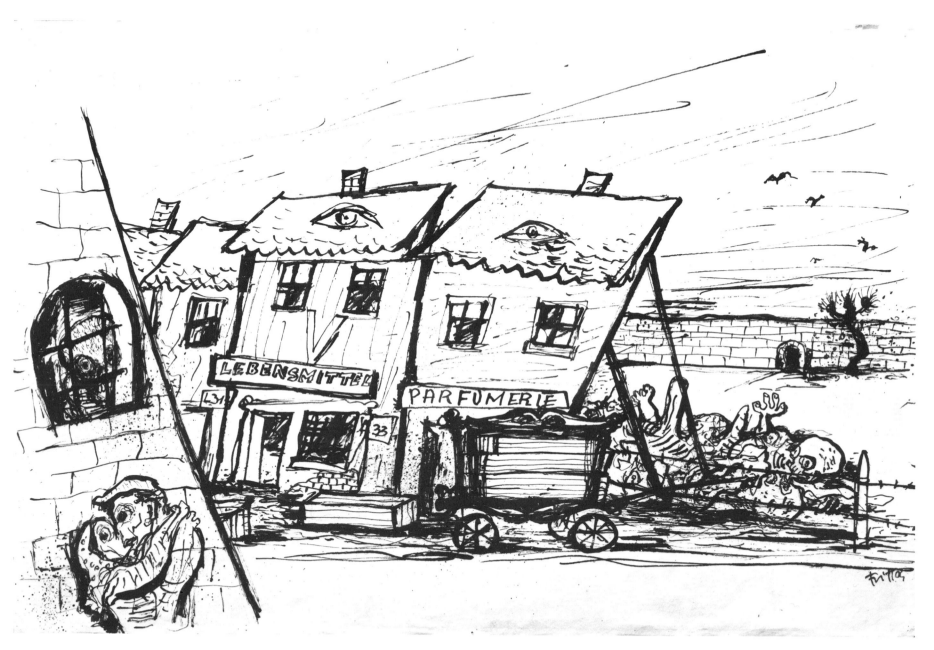

Fritta/Fritz Taussig,
The Shops in Terezín, (Potemkin Village) 1943,
brush, India ink, paper, 57 x 84.5 cm,
State Jewish Museum, Prague

pawns to be moved by propaganda constructed by the superior intellect of the leaders of the state.

Twenty years after those words were written, the power of this Nazi strategy to use visual deception to encourage passivity, in this case in and about Terezín, had become nearly complete. In his account of their imprisonment and interrogation (led by Adolf Eichmann), Leo Haas, one of the artists at Terezín, described the questioning:

> "Each of us was in a different SS-man's charge. Gunther questioned me—that I remember precisely— showing me a study of Jews searching for potato peels and saying "How could you think up such a mockery of reality and draw it?" I immediately used the same tone and explained to him that it was not, as he thought, something I had invented, but a simple study from nature, such as any proper artist is accustomed to make, a sketch of what I had happened to see by chance when I was on official duties, and which I had immediately sketched, in the same way any painter seeks for objects to paint.

> Then came the question: "Do you really think there is any hunger in the ghetto, when the Red Cross did not find any at all?"[13]

In other words, the SS was presenting their fabricated, imagined reality as the only information that could be comprehended about Terezín. No other points of view, no contradictory information was to be acknowledged, not even among themselves. In one of the most ironic twists of this most bizarre tale, Joseph Goebbels, the mastermind of Nazi propaganda, is reported to have used this myth of a prosperous "Paradiesghetto" to inflame German sentiment against the Jews:

> "While the Jews in Terezín are sitting in the cafe, drinking coffee, eating cake, and dancing, our soldiers have to bear all the burdens of a terrible war, its miseries and deprivations, to defend their motherland."[14]

With Goebbels's speech, we are reminded of the two radically different images of the coffeehouse in Terezín with which we began. One is part of the shield of banal, stereotyped images the SS constructed to deflect attention from the true purpose of the concentration camps. This shield was very nearly impenetrable; the SS control over what outsiders were able to imagine about Terezín was very nearly total. It is against this background of uniform, seamless stereotype that the achievement of the other drawing of the coffeehouse, indeed the achievement of all the artists of Terezín, must be measured. In various ways, using as many different styles as they had personalities, the artists continued to challenge the Nazis' control over what could be imagined, and therefore over what could be done.

12. Adolf Hitler, *Mein Kampf.* New York: Reynal and Hitchcock, 1939. Pages 228-230, and 850.

13. Leo Haas, *op. cit.*, page 159.

14. Cited in *Terezín*, published by the Council of Jewish Communities in the Czech lands. Prague: 1965, pp 5-6.

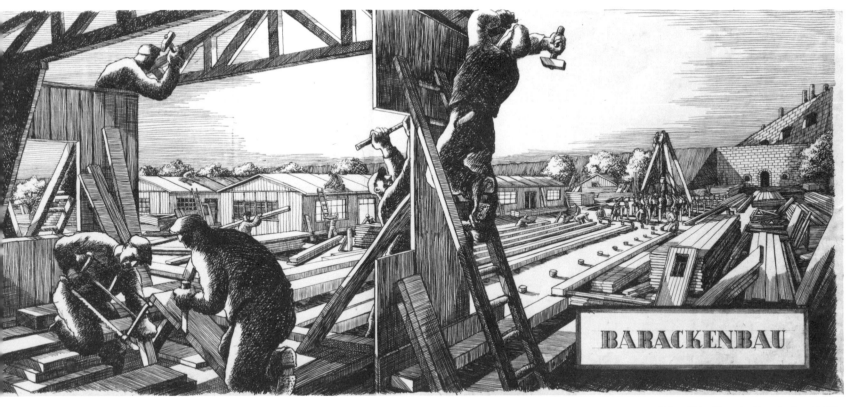

Fritta/Fritz Taussig, *Barackenbau*, 1942?,
ozalid print, paper, 35 x 79 cm
State Jewish Museum, Prague

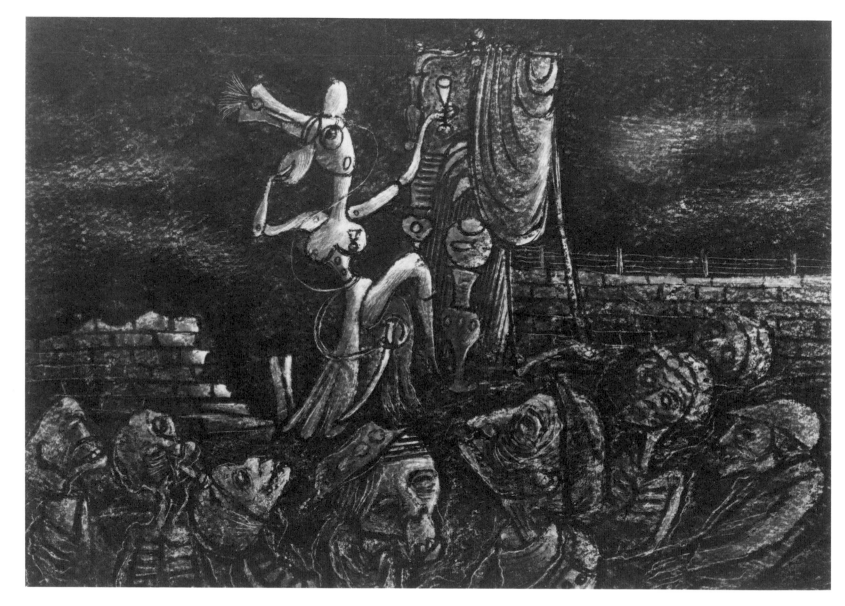

Fritta/Fritz Taussig,
The Flood, 1943-4,
scratched crayon,
ink, paper,
41 x 58 cm
State Jewish Museum,
Prague

Art in the Terezín Ghetto
Arno Pařík

THE CULTURAL LIFE OF THE TEREZIN GHETTO is a unique phenomenon, not yet completely studied nor understood. For three years, Jews in the "Protectorate of Bohemia and Moravia"[1] were gradually but systematically excluded from the life of the society in which they had lived for centuries. They were deprived of all property and human dignity, and finally deported to a small, decrepit garrison town[2] enclosed by ramparts, isolated from the surrounding world, where they were forced to exist with insufficient food and clean water, crammed into overcrowded housing and subjected to exhausting forced labor. Hundreds died daily and thousands were transported to extermination camps. As contrasted to the Nazi version of a paradisiacal ghetto, in fact the prisoners in Terezín were subjected to the same merciless mechanism of destruction that characterized the other concentration camps. Also in Terezín, Nazi policies followed unswervingly the guidelines of the final solution.

The special character of the Terezín ghetto was not simply due to somewhat less severe living conditions, nor to the striking organization of the self-governing body which, while it attempted—within the realm of the possible—to create more bearable conditions for the prisoners, nevertheless remained in fundamental matters absolutely dependent on the decisions of the SS Komandatur. Rather, the most important factor was the character of Terezín society itself that created a distinctive character for Terezín culture. For here people united by common tradition, fate and countless inner bonds came together after years of forced isolation and persecution. It was not only relatives and friends that met here, but also experts in the most diverse fields who, after years of inactivity, worked together here united by a sense of responsibility resulting from a common fate. For many of the younger prisoners, who had been isolated by Nazi repression, it was Terezín that created a community where individuals participated in common work; thus informal ties were formed which allowed the expression of natural leadership and abilities.

1. The "Protectorate of Bohemia and Moravia" was the name given by the Nazis to the part of Czechoslovakia which they had openly occupied on March 15, 1939. Slovakia had become an "independent" state one day earlier. (Transl.)

2. Terezín (German Theresienstadt) in northern Bohemia had been founded as a garrison town in 1780 by the Austrian Emperor Josef II. It functioned as a garrison town also during the first Czechoslovak Republic. (Transl.)

Thus the cultural expressions of the inmates of Terezín were in a strange sense freer than those allowed in the society of Germany and its occupied lands outside of the ghetto. Even though the majority of prisoners labored all day long, there soon emerged an improvised cultural activity, first forbidden, then in various ways delimited, but basically surviving in various forms without interruption during the entire time of the camp's existence. While some cultural life existed in almost all concentration camps, that of Terezín was distinguished by its range and quality, owing to the common cultural background and considerable cohesion of the Czech Jews, as well as to the high percentage of prominent artists of all kinds who were deported to the camp from Czechoslovakia, Germany, Austria, Holland and Denmark. In the informal atmosphere of the camp, these artists returned to their art, finding in it a humanism which had been consistently denied them. In the ghetto, cultural and artistic activities became a form of free expression, for the most part impossible in the surrounding Protectorate. Such a creative life helped overcome the unremitting suffering, providing a glimmer of hope and courage. Participation in cultural activities was not limited to professional artists, but involved the whole society: hundreds of amateurs, older prisoners and children participated in the joint presentations. Transports to the extermination camps constantly decimated these informal groups and companies, which thus could exist only for brief periods of time. And yet it was here, in Terezín, that many artists did achieve their highest creative realization.

The center for the visual artists was the so-called Drawing Office of the Technical Department of the self-government of the ghetto. The creation of the Drawing Office was aided in a great part by the director of the Technical Department, the engineer Otto Zucker, who was not only an outstanding architect but also a gifted connoisseur of the arts and of music. The Drawing Office produced construction plans and technical drawings for the various operations of the Technical and Economic Departments of the Terezín self-government, but its main task was the production of the most varied kinds of tables, statistics, surveys, plans and supplements for various weekly, monthly and annual or occasional reports and documentation relating to the activity of the self-government, constantly being demanded by the SS Komandatur.

Otto Zucker was able to involve the majority of the most significant artists of the ghetto in the activities of the Drawing Office, thus enabling them to find ways to pursue their own artistic activities as well. The leader of the Drawing Office, the Prague cartoonist and graphic artist Fritz Taussig, better known by his artistic name Fritta, had arrived in Terezín at the age of 35 with the first *Aufbaukommando*[3] on December 4, 1941. The same transport brought the youngest members of the Drawing Office, the 22-year old Petr Kien, a student of the Prague Academy of Art who was to become Fritta's deputy; Peter Löwenstein, a student of the Prague Technical University, also 22 years old; and the graphic artist František Lustig. Later arrivals included several young graphic artists and students of the Technical University, the architect Norbert Troller, Albín Glaser and Adolf Aussenberg from Prague, as well as older experienced artists like Otto Ungar from Brno, Leo Haas from Opava, Ferdinand Bloch and Oswald Pök from Vienna, Leo Heilbrunn from Prague, and later also Joseph Spier from Holland. About 15 to 20 visual artists worked in the Drawing Office at one time. Being members of the Drawing Office not only enabled painters to work partly in their profession, but also provided them with valuable materials for their artistic work, as well as permits for research visits to various ghetto enterprises and at times even visits outside the ghetto walls. Leading painters were housed with their families in the seat of the camp self-government, the Magdeburg barracks. Around them there was a group of art experts and art lovers. Thus the Drawing Office became a center of truly creative endeavors. Its activities and occasional exhibits encouraged other visual artists and amateurs to carry out their own artistic work.

In their official work, ordered by the SS Komandatur, these artists were enjoined to depict the Nazi version of the ghetto, characterized by productive labor and strict organization of camp life. From the artistic point of view, the most interesting of these official versions are the illustrated supplements to reports of the activity of the first year of the construction of the ghetto. These supplements depict the organizational schemes of the Terezín self-government and various public works carried out by the Technical Department. We have only a few of such works by Fritta, e.g. the illustrations for the project for the widening of the water

3. *Aufbaukommando* (German) construction troops, used to prepare the camp for the prisoners that were to follow. (Transl.)

Karel Fleischmann,
Old Man with Cup,
1943,
soft pencil, paper,
44 x 30 cm,
State Jewish Museum,
Prague

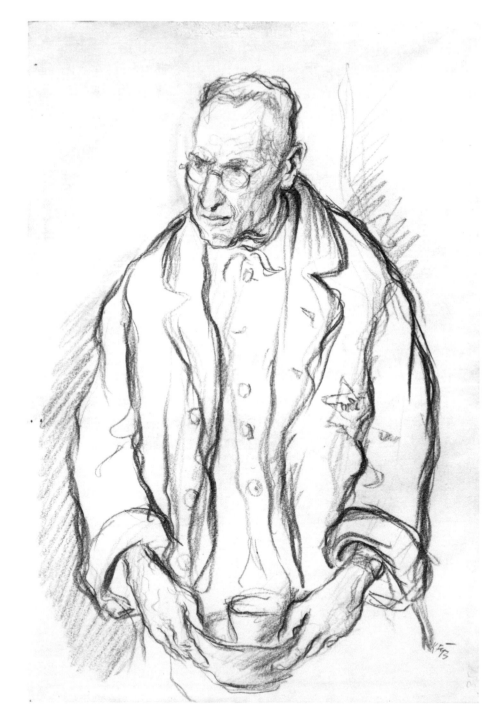

and sewage systems or the construction of buildings for war production. Fritta chose to depict the highest working efforts of prisoners, catching their athletic figures as they are bent over their labor, fully occupied by their chores. The sharply etched drawings of these powerful figures, full of contrasts, impart an uneasy inner tension, where the defiant silence conveys a threatening mood. Most of the supplements were drawn by Petr Kien, who was the most gifted artist of the drawing staff and thus most able to combine figures and details into effective light and sensitive compositions. Some of these illustrated supplements show workers and artisans at work in their shops; in others the self-governing body of the camp stressed the critical situations in health, housing, supplies, and hygienic conditions in the ghetto in the hope that the Komandatur would be forced to alleviate conditions. Additionally, Peter Löwenstein constructed statistical tables and sketches for posters for exhibits about the production of the notions shops.

It was engineer Zucker who clearly inspired the overall documentation of the activity of the Terezín self-governing body, emphasizing especially the production activities of the Technical and Economic Departments. These artistic works capture the ghetto environment through a factual documentary approach; they were used primarily for the illustrated supplements mentioned above. These include, for example, Aussenberg's cycles of drawings of the slaughterhouse and the coffee shop, Ungar's drawings of the construction of the crematorium, the bakery, the laundry and the tailor shops, Haas's sketches of the bakery, the mica factory and the dental clinic, Heilbrunn's water colors depicting the water plant and carpentry shop, and many others. The special popularity of motifs from the bakery and kitchen indicates that drawings in this area also served extra-artistic purposes. For they formed the basis of the 25 illustrations to Zucker's manuscript *Geschichte des Ghettos Theresienstadt*[4] by Fritta, Haas, Ungar, Kien and Spier, which dates most probably from the beginning of 1944. These drawings depict all important production processes and workshops, public works and construction sites, as well as health and cultural establishments organized by the ghetto self-governing body, including the gardening and the cardboard box shops which served the SS exclusively.

These illustrations were executed without embellishments, in a somewhat stylized manner. The necessity of sustaining the Nazi image of Terezín as an autonomous Jewish settlement made it impossible to depict, in these official works, the war production shops or any of the most characteristic motifs of camp life, such as the transports, the overcrowded prisoners' barracks, the endless lines for food, the suffering of the aged, or the daily stacks of coffins.

The masking of Terezín reality was the task of the so-called beautification campaign (*Verschönerungsaktion*) on the occasion of the visit of the International Red Cross Commission on June 23, 1944. The painters of the Drawing Office were forced to participate in this campaign by producing posters and advertisement slogans, the content of which was clearly absurd when juxtaposed to the reality of life in Terezín. The children's pavilion, constructed during the campaign, was decorated with very fine wall paintings of exotic landscapes by Adolf Aussenberg. Heilbrunn's anecdotal children's scenes and views of old Prague decorated the walls of the children's home and barracks. A new burial carriage with the proper curtains for the transport of coffins, as well as a large number of baby carriages for the child center were produced according to the drawings of the engineer Jiří Vogel. These of course were not used for long and were soon abandoned.

An extraordinary contributor to the beautification campaign, the Dutch painter Joseph Spier, authored the illustrations for the commemorative album *Bilder aus Theresienstadt*[5], copies of which were presented as souvenirs to Nazi dignitaries and foreign visitors. The album contained eighteen hand colored drawings, all expressing the scenario of the "beautification campaign". In addition to depictions of the activities of the self-administration related to the slaughterhouse, the bakery, the steam kitchen, the "young people's garden", the cabinet shop, the smithy, the dental clinic and the hospital gardens, the album contains Potemkin village parts of the ghetto, most of which were built exclusively for the "beautification campaign" and were totally unrelated to the real life of the ghetto. Examples include the "marketplace", planted with grass and flowers, the pavilion for the "town band", the puppet theater in the children's

4. German, *History of the Ghetto Terezín*, Otto Zucker: *Geschichte des Ghettos Theresienstadt*, 67 pp, Yad Vashem Archives Zev Sheck Collection, Theresienstadt, No. 064/7. (Transl.)

5. German, *Pictures from Terezín* (Transl.)

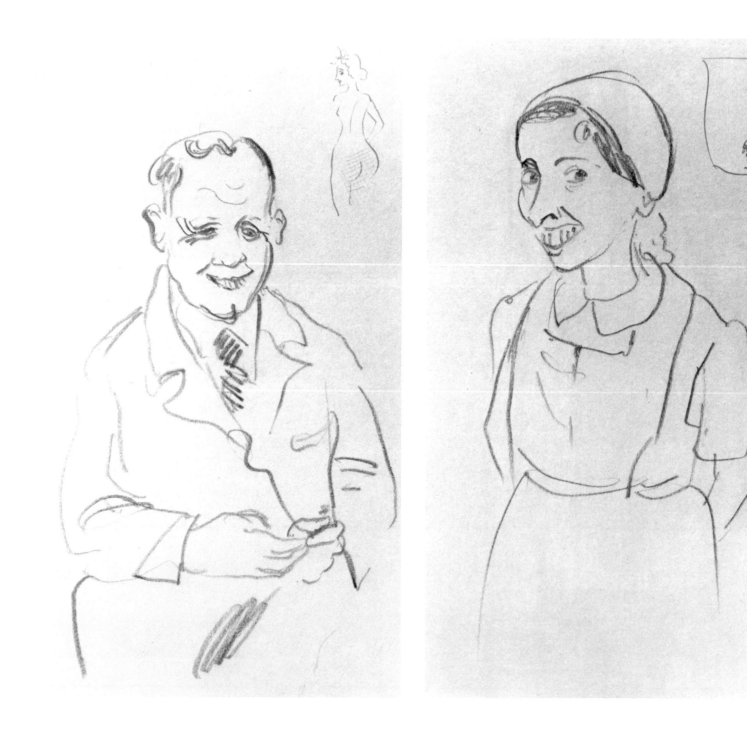

Kien did a suite of caricatures of prisoners who worked in the Terezín hospital. He included in each upper right hand corner a depiction of what we surmise was that person's daydream.

53

Left: Petr Kien, *Caricature of Dr. E. Springer (with nude)*, 1941-5, pencil, India ink, paper, 32.7 x 24.8 cm, Terezín Monument, Terezín

Right: Petr Kien, *Caricature of Mrs. Fischer (with child)*, 1941-5 pencil, India ink, paper, 32.6 x 24.5 cm, Terezín Monument, Terezín

pavilion, the "city center" with its shops, the theater in the former Sokol Hall, the coffee shop with music playing, and finally the "Bank of the Self-Administration," full of bustling life. Such scenes, as for example pictures depicting blossoming apple trees in a picturesque corner of a Terezín courtyard where children are playing and idyllic spring landscapes outside the ghetto walls, presented a fraudulent and fictitious picture of the ghetto. The illustrations are done in Spier's characteristically delicate drawing style and colored in clear and bright tones which create the impression of a quiet idyll. The album, *Scenes from Terezín*, and Spier's later drawings for the script of Gerron's film *The Führer Gives a City to the Jews*[6], are the most extreme examples of the exploitation of the artists for the propagandistic purposes of the Nazis.

In addition to the Drawing Office of the Technical Department, other official centers for artistic work were the ceramic factory, the workshops of the German firm "Lautscher Werkstätte" which was active from March 1942 to September 1943, and the so-called *Sonderwerkstätten*[7] composed of workshops producing artistic and decorative objects for the SS Komandatur. These workshops employed the Austrian painter Elsbeth Argutinská, the painters Hilda Zadikowá and Charlotta Burešová and, for a certain time, František Mořic Nágl, Ferdinand Bloch and Otto Karas. The sculptors Richard Saudek and, until his death, Arnold Zadikow worked in the ceramic workshop. These artists were forced to produce objects of art for the Nazis and their families; the SS prescribed the subject matter and the style and form of the work. Thus there were many Alpine landscapes and many sunsets; but the SS also favored family portraits done from photographs and copies of old masters. Probably these artists also created patterns for the objects produced by the cardboard box and notion shops such as lamp shades, various souvenirs, decorative boxes, games, artificial flowers and jewelry, all for German firms.

Hilda Zadikowá, an experienced illustrator, concentrated on small floral still lives, scenes from operatic productions and folkloristic scenes, as well as decorative motifs for small objects, souvenirs and bookmarks. She captured idyllic Terezín motifs in her album of drawings and her *Terezín Calendar* where each month is decorated with a miniature scene from the barracks, dormitories and courtyards. Similarly, a cycle of characteristic

Terezín scenes decorates the lamp shades by Ferdinand Bloch. They depict representative Terezín "dignitaries" such as the cook, members of the *Ghettowache*[8], a girl from the *Putzkolonne*[9], a physician, an old woman eating, and a worker, all set in their typical ambience. Hilda Zadikowá's style has parallels to the miniaturistic rococo productions of Joseph Spier and the small idyllic Terezín views by Otto Karas or the anonymous F. B. which also decorated some of the ghetto barracks. Alongside the official productions which were required to satisfy the Nazi aesthetics, artists secretly drew small pictures, made tasteful and striking metal decorative objects, wood carvings and ceramics which their authors managed to retain, smuggling them from the workshops to their living quarters or those of their friends to adorn barracks, thus substituting for confiscated jewelry and personal objects. Sometimes these objects served as exchange for food. This small-scale unofficial artistic craft played an important role in the life of the camp, answering the craving for individuality, intimacy and personal property in the impersonal void of camp life where personal property was lost.

This official and more or less permitted art work overlay more important artistic activity of quite a different character. Some artists worked in secret, behind the drawn blinds of the evening blackouts, courageously defying the Nazi propagandistic story, presenting instead the reality of the most ordinary daily ghetto life. One had only to notice the ever present overcrowding, the constant hunger, the endless food lines, the suffering and dying of the aged, the invalids and the mentally ill, and the transports which controlled the prisoners' lives with invisible threads of fear. But this required the courage to free oneself from the burden of false loyalty of prisoner to jailer and to cross the boundaries of the permitted. Such activity was strictly proscribed since the Nazis, like all totalitarian dictators, gave most importance to what they feared most, that is, any demonstration of spiritual disagreement. Not surprisingly, those who dared to carry out this step were among the most gifted. They were five: Fritta, Leo Haas, Otto Ungar, and Ferdinand Bloch from the Drawing Office of the Technical Department, and Dr. Karel Fleischmann, a physician from České Budějovice[10] who was employed in the health administration of the camp. Although they were of different origins, training and artistic orientation,

6. German, *Der Führer schenkt den Juden eine Stadt*. Czech, Darované město (Transl. Information provided by A. Lustig).
7. German, special workshops. (Transl.)

8. German, the ghetto police. (Transl.)
9. German, cleaning brigade (Transl.)
10. A town in southern Bohemia. (Transl.)

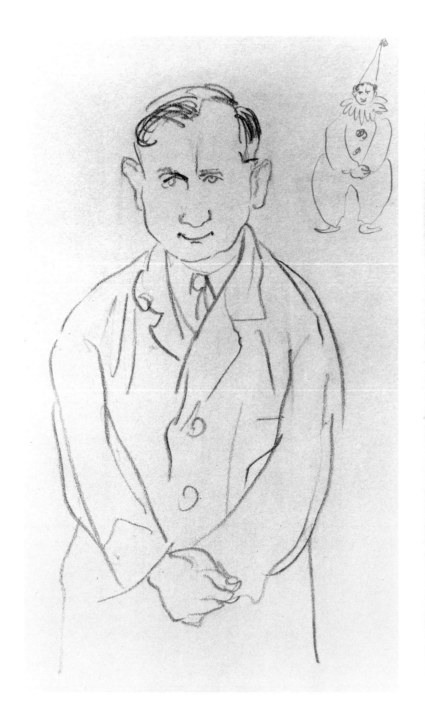

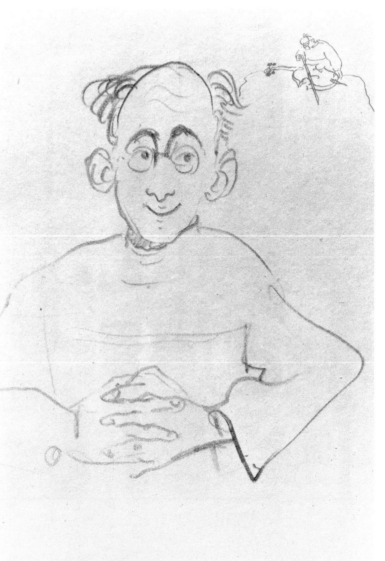

Left: Petr Kien,
*Caricature of Surgical
Assistant (with clown)*,
1941-5,
pencil, India ink,
paper, 32.6 x 24.6 cm,
Terezín Monument,
Terezín

Right: Petr Kien,
*Caricature of Dr.
Stamm (with cellist)*,
1941-5
pencil, India ink,
paper, 34.2 x 24.3 cm,
Terezín Monument,
Terezín

their drawings and themes are mutually complementary, creating a picture of ghetto life, very different from the official and permitted one.

Fritta was deeply involved in showing the bitter experience of suffering and poverty in the ghetto, and he did not hide it even in his official works. In his sketch books we find no detailed pictures of reality; objective external relations of reality did not interest him. The former cartoonist concentrated instead on a single significant motif, nurtured it through careful small sketches in order to find its truest ideogram, and only then—in a flash—endowed it with its final shape. Thus his sketches are most effective where he transforms a realistic motif into an expressive symbol imbued with the absurdity and senselessness of the deformed lives in the ghetto which had lost their past and meaning. He focussed his motifs sharply, dramatically, uncompromisingly, and with brutal frankness. Thus the silhouettes of trees, luggage left behind from a transport, lonely figures of elderly people, their eyes staring into empty space, a funeral wagon, the false fronts of houses, or figures becoming puppets, all these are transmuted into images of death, expressing a phantasmic ending of the world. Fritta was the artist who most powerfully expressed the conflict between the reality of Terezín and the propagandistic falsehoods about it; this became the thematic center of his work. His penetrating vision of the horrors of war and the apocalyptic destruction of the world far outpaced that of other painters. The humor and human understanding with which he was able to see this world is best demonstrated by the little picture book which he drew for the third birthday of his son Tommy, in January, 1944.[11]

Fritta most intensely influenced Leo Haas, who shared his caricaturizing vision and his black and white drawing technique. But even Haas's critical scenes within the hospital, the barracks, the courtyards peopled with groping figures of blind men and women and cripples, are more literal, softer and more bound to realistic detail than Fritta's. After the war Haas constructed more complex compositions from many of these scenes, creating a striking many-sidedness of motifs through juxtaposing the grotesque features of the Terezín panorama to the decorative character of his presentation. In Terezín, Haas also created a large number of descriptive and documentary works, including often very charming pictures of children and caricatures of members of the self-administration. In contrast

to the others, Otto Ungar was primarily a painter, and in Terezín in most cases he worked with watercolor, gouache or tempera. His drawings also have a dominant documentary component which pervades even his most ambitious compositions. His realism abjures simplification and exaggeration. Rather the strength of his creations lies in a realism that conveys a powerful experience. The striking colors of his gouaches in dark and brittle tones on a characteristically greyish foundation effectively and powerfully impart the mood of hopelessness and tragedy characterizing ghetto life. Everyday subjects, still life from the barracks, faces of old women as they stand in food lines, the hesitant stance of a blind man, a religious service of elderly people in an attic, or an empty dormitory as it looked after the departure of a transport, convey the whole microcosm of human suffering in the ghetto.

Ferdinand Bloch, the fourth member of this group, also remained faithful to a descriptive vision, not attempting large canvasses, nor trying to capture exceptional subjects. The dominant mood of his drawings is hopelessness and quiet desperation. He returned constantly to the motifs of the arrival of transports, prisoners standing silently in line, views of overcrowded dormitories, nervous glances of old women, farewells over a coffin, nocturnal funerals, and scenes of prayer meetings improvised in attics. His peculiar drawing style, sometimes seemingly clumsy with unsteady lines, expresses the misery of life in the camp with great sensitivity.

On July 17, 1944, shortly after the end of the "beautification campaign" and the Red Cross Commission visit, these four painters together with architect Norbert Troller and art collector Leo Strass were arrested and interrogated by the Gestapo. The infamous Eichmann participated in this cross examination. The artists had already managed to brick most of their works into walls or to bury them in various places in the ghetto before their arrest. It is unclear how their activity had been betrayed, but in any case the Nazis were well informed about the nature of their work. The question of whether the artists intended this work to represent subversion or to be an artistic fiction or simply a representation of reality was not of interest to the Nazis: what these people had put on paper in fact spoke all too expressively. That same evening the painters and their families were deported to the Small Fortress.[12] Here Ferdinand Bloch was murdered first,

11. Fritta, *Für Tommy zum dritten Geburtstag*, Neske Verlag, Pfullingen, 1985.

12. This "Kleine Festung" was the prison of Prague's Gestapo and of Terezín; it was part of the old fortress complex, not far from the ghetto.

Left: Petr Kien,
*Caricature of
Dr. Borgzinner
(with ship)*, 1941-5,
pencil, India ink, paper,
34 x 24.4 cm,
Terezín Monument
Terezín

Right: Petr Kien,
*Caricature of
Dr. Elsner wearing hat
(with nude)*, 1943,
pencil, India ink, paper,
36.6 x 24.6 cm,
Terezín Monument,
Terezín

followed by Hansi Fritta, Fritta's wife. The others were deported to Auschwitz where, by a miracle, Haas survived as well as little Tommy Fritta, Frida Ungar and her seven-year old daughter Zuzana. This tragedy demonstrates once more how the Nazis feared any truths that pierced the clouds of their propaganda.

Next to Fritta and Ungar, the most important among Terezín painters was Dr. Karel Fleischmann, who occupied a responsible position in the Terezín health administration. Since childhood Fleischmann had been devoted to drawing and writing. In his rare free moments in Terezín he sketched untiringly with pencil and pen, capturing life and the human crowding around him. As a physician he regularly saw a world and events which others faced only rarely. His drawings exposed the most hidden and remote corners of the ghetto. For this reason his work, created secretly, is today the largest and most multifaceted document of life in the Terezín camp. In contrast to the work of the other painters who mostly depicted scenes without human figures, Fleischmann's subjects are entirely people in action. In quick and dramatic strokes he captured human transports as they occurred in Terezín and left for the death camps, lines of people waiting to be registered or to pass through the *šlojzka*,[13] individuals waiting in food lines or collecting garbage, overcrowded dormitories and attics, a lecture hall and throngs listening to music in the park. Movement continues in the unsteady lines of his drawings, outlining human figures and crowds and in long corridors, in cell-like rooms, and the streets of Terezín. Fleischmann was deported to Auschwitz, in one of the last transports, in October 1944, where he perished.

In addition to the conscious attempts to document the Terezín environment and life both in the official production of the Drawing Office and in the secret work of the artists which differed both in motif and freedom of expression, there was another creative area, probably the most widespread one. This lay primarily in the activities of the older artists and of amateurs. This corpus was not as clearly marked ideologically, but expressed the inner needs of the artists themselves. While most examples of this group of works are of a predominantly documentary or commemorative character, the ever present and disturbing reality of

Terezín is apparent. For the most part these individuals lacked access to the production enterprises of the ghetto, and they painted and sketched in private, capturing primarily the microworld of the housing barracks, the little courtyards, secluded nooks and corners of the ghetto. Thus we see life in the camp from a more intimate perspective and in greater detail.

František Mořic Nágl authored the largest cycle of watercolors and gouaches, which depict scenes from the courtyards and dormitory barracks where individuals were consigned to two- and even three-decker bunks. There also remain the oil paintings of courtyards and street scenes by Bedřich Wachtl, showing lonely figures of aged prisoners in dark earth colored tones; they convincingly display the gloomy atmosphere of the ghetto. The considerable collection of small documentary watercolors by Eduard Neugebauer, one of the amateur painters, imparts a fresh character to its great diversity of subject matter. There are also the careful ghetto documentaries of Ludvík Wodak, primarily watercolors showing the courtyards and walls with a little greenery. Then there is the anonymous painter known only by the initials J. L. who painted watercolors of barrack yards and the courtyard of the hospital. Another anonymous painter, who signed the initials E.K., drew sentimental, even kitschy drawings of private rooms and detailed depictions of his own cell of a room and other habitations, as well as the courtyard of Building Q314.

Portraiture was another very important genre in the Terezín ghetto, representing a whole gamut of shadings of expression and technique. Some artists devoted themselves primarily to portraiture. For example, Petr Kien continued his pre-war interest in portrait painting. In addition to a few canvasses, some of his portrait drawings are preserved. In these he concentrated on capturing the inward movement and psychology of his subjects. He favored exceptional, especially artistic, personalities, as exemplified by a cycle of delicate and sensitive pen drawings of Terezín musicians and composers which convey with subtlety their individualities. Another portrait artist, Max Plaček, drew more than five hundred small caricatures, which represent a gallery of Terezín prisoners, including especially important figures and artists. Professor Mořic Mueller, who worked in the clinic of the hospital of the Zenin barracks, sketched

13. *Šlojzka* (from German *Schleuse*, a river or canal lock) was a barrier through which arriving and departing transports had to pass. (Information provided by Arnošt Lustig, Transl.)

Petr Kien,
Portrait of Mr. Stein,
1941-45,
chalk, paper,
63.4 x 46.2 cm,
Terezín Monument,
Terezín

hundreds of portraits of dying, aged prisoners in order to capture the irreclaimably disappearing likenesses of these victims and their individual fates. Mueller's drawings remind us of some likenesses by Malvína Schalková, the well-known portraitist of members of Prague and Vienna aristocratic society, who drew faces of lonely old women in the Terezín barracks. Another professional portraitist, Charlotta Burešová, left a series of portraits of members of Kurt Gerron's cabaret[14].

One can hardly judge art in Terezín by the autonomous aesthetic criteria of modern art. It is closely tied, in all its manifestations, to the conditions of its origin and to its function in the life of the ghetto. Only thus did it succeed in capturing and preserving life in the camp in its totality, complexity, and multiformity. The most important Terezín painters are those who courageously disregarded the strictures of the Nazi image of Terezín as a model ghetto, who rebelled against humiliating Nazi edicts in favor of truth and creative freedom, and who were prepared to suffer the consequences of their actions. There are also signs of this rebellion and struggle in the works of many other painters. But in many of them there appears to be an attempt to see their position in a somewhat positive light even at the price of an escape from reality, namely through painting in an idealized fashion. However, this tension between reality and idealization pervades all Terezín creations, sometimes more and sometimes less clearly visible. We can not *a priori* exclude any of the artistic creations from the total picture of the ghetto, not even those depicting an official reality, since these at least inform us of the Nazis' distorted demands. Thus we include even the exhibits of the beautification campaign; for they show the shameless mendaciousness of Nazi propaganda. Nor can we overlook the products of the so-called "artistic workshops", which appear to have conformed most fully to the aesthetic norms of Nazi taste; they also included decorative objects and souvenirs for use in the ghetto. Nor can we neglect the work of the amateurs, although their work of course is not as ambitious in scope or subject matter. Nevertheless they present very detailed and thus valuable information. Only in its totality does the art of the ghetto truly present a complete picture of its life.

Translated from the Czech,
annotated and edited by Thomas G. Winner and Irene Portis-Winner

14. Kurt Gerron was a famous German actor, who played in the film *The Blue Angel* opposite Marlene Dietrich and Emil Jannings. In Terezín he ran a cabaret, Carousel, in the so-called Hamburg barracks. (Information provided by Arnošt Lustig. Transl.)

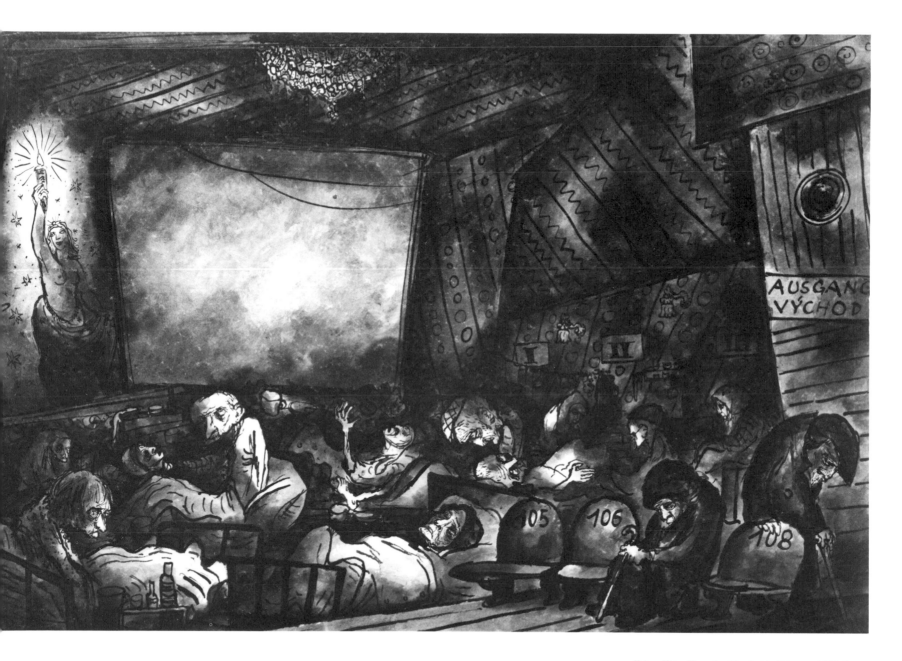

Fritta/Fritz Taussig, *Hospital in Cinema*, 1943-4,
brush, India ink wash, paper, 57 x 85 cm,
State Jewish Museum, Prague

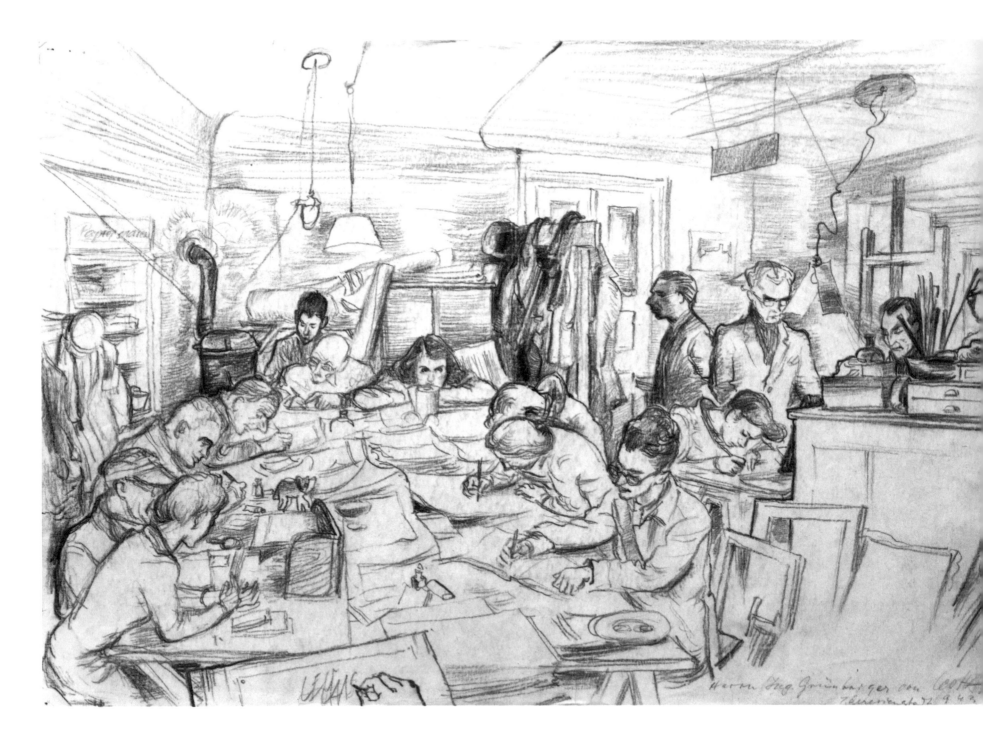

The affair of the painters of Terezín
Leo Haas

On a June day in 1944 the painters and graphic artists, Bedřich Fritta, Otto Ungar, Felix Bloch and Leo Haas were called to the "Council of the Elders," to Mr. Zucker in the Magdeburg barracks, where the "Mayor's Office" of the Terezín ghetto was located. There he disclosed to us that we were to report the next morning to the commander of the SS. Mr. Zucker, who had certainly been sworn to secrecy, merely made the suggestion that we should pack warm underclothing and take a coat, for we might have to wait in the cold cellar of the commander's office, and "it might possibly last quite a while" before we were questioned—this was just a precaution, he said, so that we would come to no harm! Next morning we found there the architect Troller and an old man, Mr. Strass from Náchod, and I must say that the precautions of Mr. Zucker were justified. It really did last quite a while! For me and, if I am correctly informed, for Troller it lasted to the 9th and 22and of May, 1945, and for the others all eternity.

What was it all about?

The Jewish leaders of the ghetto, who were responsible to the Gestapo for everything and could not take the least decision, except under the greatest danger, and with SS approval, had a sort of drafting office as part of the construction work in the ghetto, where some of the necessary technical drafting for building purposes was done. But it was also a place where artists from different countries (Dr. L. Heilbrunn of Brno, the graphic artist Pöck from Vienna, Petr Kien, etc., in addition to those I mentioned above) were able to carry out all sorts of drawings and writing, necessary for bringing this phantom life to an end. For example, I remember that I myself drew a series of posters that were addressed to the smallest inmates of the ghetto, with the slogan, "Children, don't do that," trying to help in regard to rules of hygiene and general training of children. This team was headed by the splendid graphic artist Bedřich Fritta of Prague, who was at first protected from the transports as AK-man.[1]

Naturally, we were soon making use of this activity that was sanctioned by the SS (since we were employed by the "government") and which we exercised as part of our work, to actually make studies and

1. *Aufbaukommando* (work group that exempted its members from inclusion in transports).

sketches of life within the walls of the ghetto, camouflaged as official work. Especially Fritta and I myself were constantly encouraged to create this unique documentary testimony. The members of different cells would use the traditional Czech saying, "Write this down, Kisch !" Well, this encouragement was not necessary. Even before this I had not been idle when, after my arrest in Ostrava, I had been working in the construction of the first European camp for Jews (in 1939-1940) in Nisko on the San. I had brought from there a thick folder of documentary sketches made in a similar way. I was driven all the more by the shocking experiences within the ghetto walls to be constantly on the look-out, wherever I could, sketch pad in hand.

Of course we were often in danger and had to use the greatest caution in drawing, hiding from the SS men that were spread out all over the town, keeping to attics or somewhere in a crowd. Fritta, Ungar, and often Bloch and I were so oppressed by the horrible surroundings that we devoted ourselves to our "office duties" in the day and then night after night gathered in our darkened workroom, where our sketches matured as a cycle. At that time and under these conditions (perhaps it is only today that I realize what great danger we were then working under) the cycle of 150 splendid drawings by "Fritzek" (Fritta), for instance, came into being. Today they hang in the Jewish Museum in Prague. This was also how I made my cycle of drawings of Terezín, some of which are in the possession of the Czechoslovak government, but a large number of which were sent on an information tour of the United States; others are among my property and still others serve as a basis for subsequent works and thus help in some attempts to depict Terezín life. At that time we came in contact with the above-mentioned Mr. Strass, a businessman in Náchod, whose "Aryan" family kept up underground connections with him. He told us that this contact was made through some courageous members of the Czech gendarmerie, who served in the ghetto and helped all they could. I myself came in contact with two brothers—I think their name was Přikryl. Strass, who was a passionate collector, especially of Czech art, often begged drawings from us that then were sent out of the ghetto by the same route that food and tobacco came in. We thought that in this way something of our documentary material would survive, even if we did not. Then we learned that successful contacts had been made with foreign countries and that our works had been sent beyond the borders of the territories ruled by the Nazis. In our enthusiasm we undoubtedly underestimated the danger that had thereby increased, and we worked even more passionately and intensively on our presentation of the ever more dismal "life" in the ghetto.

Things went on like this for a full two years. Then—I think it was in the spring of 1944—the visit of an especially important Red Cross commission from Switzerland was announced. I believe I forgot to say that we had been told that our drawings had gone to Switzerland. For conspiratorial reasons we could not—consciously—meet with our colleagues. The preparations for this commission's visit, on which the Nazis seemed to place great value, in the precarious situation they were already in by that time, we also sketched.

Then the visit of the Red Cross was over. Among the initiate it was rumored that the SS leaders were dissatisfied with it—dissatisfied and suspicious. Evidently the representatives of the Red Cross were not content with the streets that had been polished clean with Jewish persons' toothbrushes, and wanted a look behind the scenes of the Potemkin village. They seemed to have been well informed. There has been no success in tracing their contacts, but the fact is that a few weeks after the visit came the orders from Mr. Zucker with his troubled warning, which introduced this report.

I do not know to what circumstances it is due that the SS made no raid on our rooms. I think it was to show their mastery of the situation, and to avoid any irritating surprise. Our employment in the "government" gave us the only privilege, but one that was not to be discounted, that we were lodged in barrack rooms divided off by lath walls and so aroused the illusion that we were living in our own homes. When things had gone on in this way for a half year, we succeeded in saving a large part of the rest of our work. With feverish efforts, and with the help of a building expert, engineer Beck of Náchod, we succeeded in prying out a part of the wall in our room and walled in the drawings. In a few hours it was finished, but I did not forget to leave some unimportant drawings lying about, so that if there was a house search by the Gestapo, I could stop the mouths of the wolves to some extent. Fritta's works were also buried by friends in a tin case in a farm yard, and were saved in this way.

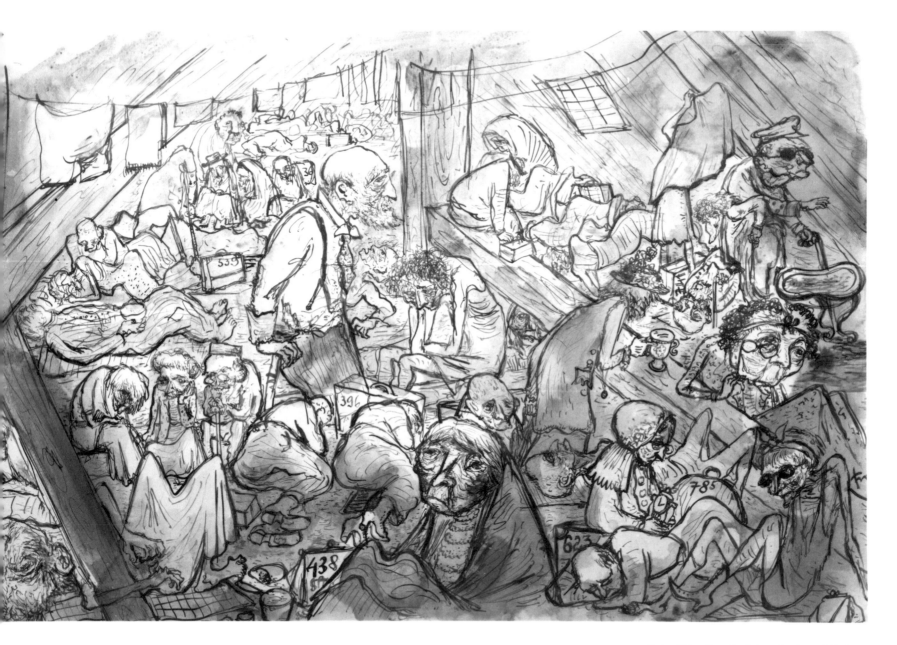

Fritta/Fritz Taussig, *Life in the Attic*, 1943-4
pen and ink, paper, 55 x 84 cm,
State Jewish Museum, Prague

After a short discussion with each other, when we had heard Zucker's report, we naturally decided that our activity as "documentarians" was the basis for our questioning, and this was shown to be quite correct.

We reported on the morning of—I think—June 17, 1944 [2] (there is an assignment card to the police headquarters in the card-file of the Jewish Religious Communities office in Prague) at the office of the Gestapo head and were immediately herded down to the cellar.

After a long wait, we were hustled up to Rahm's room. Besides Rahm there were present: Moes, also known as the "bird of death," also Gunther whom I recognized immediately from my time at Nisko, for there he had headed the organization of the transports, together with his brother in Ostrava. But then still another person came in, whom I again recognized from his inspection trips to Nisko: he was Eichmann. I knew, of course, that this meant no good for us.

I am trying to make as dispassionate as possible a portrayal of the "Affair of the Painters from Terezín," as I found, after our return in 1945, our case was called. And here also I cannot speak of any brutalities. Eichmann, in opening the questioning, gave the impression rather of one who was deeply hurt that his noble intentions for the Jews could be so slanderously interpreted. And it was in this sense and this tone that he spoke. Then the questioning was continued by Gunther and Rahm. Both followed Eichmann in using an oily smooth, soft tone, and carried on a sort of discussion on the history of art with us. Naturally the undertones sounded that much more dangerous. They had from two to three drawings from each one of us four painters as evidence. Each of us was in a different SS-man's charge. Gunther questioned me—that I remember precisely—showing me a study of Jews searching for potato peels and saying, "How could you think up such mockery of reality and draw it?" I immediately used the same tone and explained to him that it was not, as he thought, something I had invented, but a simple study from nature, such as any proper artist is accustomed to make, a sketch of what I had happened to see by chance when I was on official duties, and which I had immediately sketched, in the same way as any painter seeks for objects to paint.

Then came the question: "Do you really think there is hunger in the ghetto, when the Red Cross did not find any at all?" The subsequent questions were aimed at making us name the people who had been our

contacts with the outside world and tell whether we thought they formed a Communist cell. Since we denied this and shifted everything onto our artistic interest, the questioning was interrupted and we were taken again to the cellar. I do not know how long we lay there. After some hours, Gunther and Moes appeared again, and this time the latter had a long pistol in his hand. Their tone was much more like the familiar Gestapo manner, and now their sole aim was to find out our connection with some Communist cell. We could go home immediately if we would tell all the names of those who had "led" us into this activity. Then Moes, after brandishing the revolver in a terrible way, broke off the questioning and said in a German that still rings in my ears, "Just stop it! You'll get nothing out of these fellows." (It is certainly very interesting from a psychological point of view that one often retains some not very essential fragment of conversation from situations that could be a matter of life and death.) Now we were left alone and felt we'd never get home again.

It had already got dark in the cellar when we heard a heavy truck pull up in the early evening. Soon thereafter came the typical bawling of the SS guards as they clattered into the cellar and drove us with the butts of their guns and with blows up the stairs and onto a place densely covered with trucks, in which were our wives and children, crying and yet happy to see us again. There was Fritta's wife and three-year-old boy Thomas, Mrs. Bloch, Mrs. Ungar with her five-year-old daughter, my wife Erna, then the aged František Strass from Náchod and the architect Troller who was sent away with us. As architect he had had to carry out the special demands of the camp command and in some way had not suited the gentlemen.

The whole transport went to the Small Fortress that was situated in the vicinity. There we first had to stand with our faces to the wall, the children as well. Then we men were put in one cell and the women and the two children in another, but not in the women's court.

I do not want to recount here the suffering we had to endure. This is impossible for lack of space. I believe that Ungar was the first to be sent from the Small Fortress, and I think Bloch was beaten to death on the spot, then Troller went to Auschwitz also, and I heard that he survived this, but lives somewhere overseas. The aged Strass also held out for a while in Auschwitz, I believe, and there he and his wife perished. Mrs. Ungar and her daughter survived the horror (in Auschwitz, too, I believe), while

2. Actually, July 17, 1944.

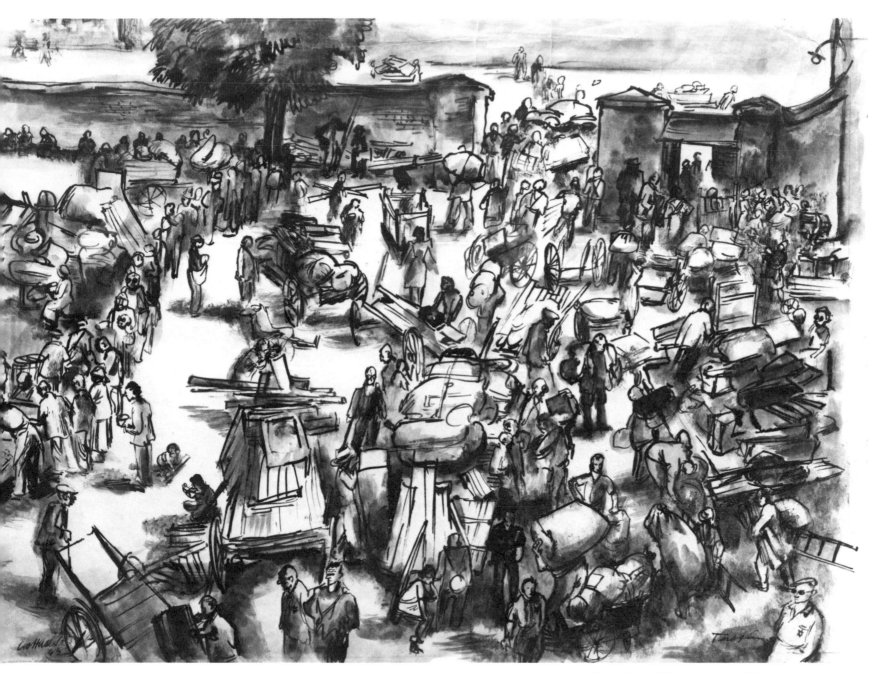

Leo Haas, *Moving of Sudeten Barracks*, 1943,
India ink, paper, 44.5 x 61 cm,
Terezín Monument, Terezín

Otto Ungar died of typhus, in Buchenwald after liberation, I believe. There remained in the Fortress Fritta and I, our wives and little Thomas Fritta.

In the course of our daily labor at the "Richard" works in Litoměřice I was so beaten that as a result I had a serious phlegmon, among other things, that was cut out by our cell policeman, Dr. Pavel Wurzel, with the assistance of Julius Taussig (a furrier from Teplice), who could not go to work there because of a broken leg— without sterilization, without anesthetic, with a rusty saw. We from the "Eastern nations" were not allowed access to the sick bay or to be visited when ill. While I was going through the crisis of the wound's healing I lay hidden in old rags, where our yard commander Oberscharführer Rojko found me and drove me with blows into the bunker cell and forbade anyone to give me food. I was there about a month, then more and more fellow prisoners were brought in, among them the severely ill Fritta who had dysentery. I had been saved by the solidarity of my fellow prisoners (Jewish and non-Jewish), above all our yard trusty, the Czech General Melichar. Then, before the whispered rumors of our liquidation by Pindja and Rojko came true, we two received an indictment from the Prague Gestapo, that spoke ambiguously of "Horror propaganda and its dissemination abroad," together with a warrant for our arrest that we were to sign voluntarily, "for fear of the just anger of the German people," and which bore the remark that was familiar to us: "R.u." (return not desired).

The very next day (it was towards the end of August) we rode in cell cars attached to an express train with a stop in Dresden for questioning, then through what was then called Breslau to Auschwitz. Fritta was very feeble and was scarcely able to move, but had to be taken to the toilet because of the dysentery every quarter hour. I offered to care for him, and thus my hand cuffs were temporarily removed. For instance, I carried him, almost on my back—he was a good head taller than I—in Dresden, through half the city to the police headquarters. In Auschwitz, where we were taken to the so-called Stone Camp Auschwitz I, as political prisoners (not for racial reasons, what a nuance!), the prisoners' organization was already functioning. Fritta was taken directly to the sick bay by the architect Hanuš Major and Dr. Pavel Wurzel, who had become doctor for the sick bay in the meantime. I visited Fritta there a few times in the next

eight days. He had almost completely lost consciousness and on the eighth day he died, a horrible spectacle of decay, covered all over with oedema, with complete decomposition of the blood (sepsis). I went on to Sachsenhausen in a Sonderkommando of the Reichssicherheitshauptamt. Together with Czech pals like Adolf Burger, Stein-Skála, Karel Gottlieb, Dr. Kaufmann-Horice, and with the well-known Berlin publicist Peter Edel, I followed all the movements of this Himmelfahrt (heaven-bound) command up to liberation in May 1945, in Ebensee, Austria.

Meanwhile my wife Erna, although her health was completely undermined, remained among the living and returned home. She had spent the year with little Thomas Fritta in solitary confinement in the Fourth Yard of the Small Fortress, where Fritta's wife Hansi had died, miserably ill. We later adopted Thomas. In 1955, my wife Erna died, after having barely existed for ten years, one hundred per cent disabled after her imprisonment.

Immediately after we had returned we sought out the places in Terezín where we had hidden our works. We actually found them again, unharmed. Later I was able to show these (they were published in almost all centers of publication throughout the world), with the splendid drawings by Fritta and some by Ungar, as well as some strongly incriminating drawings by a Terezín doctor, Dr. Fleischmann, who had managed to save his, too. Added to other evidence, this was strong testimony on the "final solution" engineered by Eichmann and Globke.

I feel it my duty to accuse, until the end of my life, the fascist murderers named in my report, and to accuse the men in the background—in the name of all the victims, I in my own name, and above all in the name of my friends who did not return, the painters of Terezín.

Fritta/Fritz Taussig, *The War*, 1943-4,
brush, ink, pastel, crayon, paper,
75 x 105 cm,
State Jewish Museum, Prague

Friedl Dicker-Brandeis,
Portrait of a Man, 1941-2,
pastel, paper
State Jewish Museum,
Prague

Friedl Dicker-Brandeis: the art educator as hero

Al Hurwitz

Of the 15,000 children who passed through Terezín, fewer than one in ten survived. The person assigned as coordinator of repatriation for those under the age of 14 was Willy Groag, now living in Kibbutz Masanit in Israel. In August of 1945, Groag found two suitcases of drawings in Terezín which he delivered to the Jewish Community Center of Prague. It took ten years for someone to study their contents and to appreciate their unique record not only of the hearts, minds and memories of the child artists who produced them but of the remarkable woman responsible for their creation. The woman was Friedl Dicker-Brandeis. What follows is the story of Friedl and her students.

Introduction

This paper began in the autumn of 1983 when I read Mary Costanza's "The Living Witness." The book dealt with art produced in concentration camps and made a reference to the art of children. The phrase that caught my attention was as follows: "teachers such as Bedřiška Brandesová who dedicated their last days to distracting the children by giving them secret lessons in art."[1] I have always felt a personal kinship with art teachers wherever they work and have spent a good part of my life tracking them down in the art rooms of the world, be they in student centers, museums, city streets or classrooms. Until reading Costanza's book, it had not occurred to me that art teachers worked in ghetto areas or death camps. Without waiting to finish the book, I opened a new file with the title "Brandesová-Terezín" and began my search for yet another neglected contributor to the history of art education. It took me a year of correspondence to discover that the person Costanza referred to was, in fact, Friedl Dicker, the wife of Paul Brandeis (the use of the "ová" at the end of a name is Czechoslovakian practice). This was revealed through the number of survivors who had no knowledge of the Brandesová mentioned in Costanza's book, but who knew a great deal about another art teacher with a similar name. My inquiries were carried out not only through correspondence with survivors of Terezín and the directors of the two major collections in Europe, but through the study of translations of

1. Costanza, Mary (1982) *The Living Witness: Art in the Concentration Camps and Ghettos.* New York, Macmillan, p. 77.

articles in both published and manuscript form. One source led to another—each piece of information drawing me in yet another direction, and as everyone who has ever written a biographical study knows, detection and serendipity go hand in hand.

In 1985, I visited Israel to study the Terezín drawings in Yad Vashem, and to visit the Holocaust Centre, and in August of 1987 I went to Prague—to visit the Town Hall and the State Jewish Museum, where I had the good fortune to speak with most of my correspondents, to receive a personal viewing of Friedl's work as an artist and to study the drawings of her pupils in an exhibition area of the High Synagogue. I was also driven to Terezín by a former inmate so that I could witness first hand where Friedl lived and worked. From Prague I went to Berlin to secure a catalogue of an exhibit of Friedl Dicker-Brandeis's work and that of her associate Franz Singer.[2] I also delivered photos of newly discovered works of Friedl to a curator of the Bauhaus Archiv Museum in Berlin and learned that a second exhibition is planned to accommodate the collection in both Prague and Berlin. One more visit awaits me, and that is to return to Israel to Kibbutz Givat Hayim Ihud where a few survivors of Terezín and Auschwitz live. I hope one or two will remember Friedl as a teacher. This study is not complete. I hope that after reading it, someone will write to correct me or to add to my data and in so doing, enable me to refine the process of verification.

Friedl Dicker-Brandeis was a real person whose ideas and behaviour were shaped by certain forces of history and culture. In order to understand her work, we need to understand the art, the politics and the educational thinking of her time. The purpose of this paper will be two-fold: to provide an account of her life and to put her career into the perspective of certain historical forces which have a bearing on the history of art education in Germany.[3]

The facts of Friedl Dicker-Brandeis's life are easily verifiable and run as follows: she was born on 30 July 1898 in Vienna of middle-class Jewish parents. Considered gifted as a child she studied with Johannes Itten as early as the age of 14 and in 1919, the year Itten joined the Bauhaus in Weimar, she formally enrolled as one of his students. While there, Friedl was a member of Itten's first foundation course in design. She was regarded highly by both Gropius and Itten and taught at the school while a student.

Prior to studying with Itten, she attended Franz Cizek's classes at the Vienna Kunstgewerbeschule. Although the methodology of Itten and Cizek differed, the two shared a set of beliefs which helped to determine the course of Friedl's thinking that was adhered to in her own classes in Austria, in Czechoslovakia and which found its fruition in Terezín.

Upon graduation in 1923, Friedl and Franz Singer, a former school associate, started their own workshop in Berlin, "The Workshop of Visual Art," producing art on commission. She and Singer returned to Vienna to continue their design consultancy and during this period Friedl gave private instruction in drawing, basing her methods, in part, upon Itten's foundation course. For the next six years she continued to exhibit, to win awards and to become actively involved with the Austrian Workers Movement. The period between 1923 and 1934 was critical in her development as a person as well as an artist since it was during this period that two interests emerged—an interest in the teaching of art and a strong acceleration in political activism. It was her arrest in 1934 for political activities that caused her to flee Vienna for Prague where she taught, worked as a designer, and continued to engage in political activities against the Fascists. Her marriage to Pavel Brandeis gave her Czechoslovakian citizenship and enabled her to continue her work.

It was during the period between her stay in Czechoslovakia and her London exhibition at the Royal Arcade (1940) that her interest in art education became more intense and correspondence during this time with a close friend[4] reflected a growing preoccupation with the role of art in the education of children as well as adults. Friedl Dicker-Brandeis's interests were wide by today's standards. Upon leaving the Bauhaus, her

2. Exhibition Cat. "Friedl Dicker; Franz Singer." Berlin, Bauhaus Archiv, Klingel Hofstrasse 14, Berlin G-1000, 30.

3. Among those who have given generously of their time in assisting me with this study, and to whom I extend my special thanks, are Dr. Arno Pařík, the staff of the Bauhaus Archiv Museum, and Prof. Jeri Wehle, who responded with such alacrity to correspondence, telephone calls and telegrams.

4. Unpublished correspondence with Hilda Kothyanna.

Friedl Dicker-Brandeis,
Flowers in a Glass of Water, 1943,
watercolor on paper,
30 x 22 cm,
Collection of Anna Sladkowa

professional career reflected a validation of the Bauhaus philosophy, since the catalogue of her work shows her functioning as an architect specializing in day-care centers and as a designer of interiors, books, furniture, and the theatre (both settings and costumes).

As Hans Wingler wrote:

Those who came to the Bauhaus did not only do so for thorough instruction. To belong to the Bauhaus meant to adhere to progressive ideas in the arts and to be conscious of political responsibilities. Extremism of the political right was shunned by the Bauhaus people. Small wonder that only a few of them sympathized with Hitler, even after 1933. Many, especially the established Bauhaus artists, emigrated. Those who stayed in Germany suffered professional restrictions and even personal persecution. As far as is known, twelve Bauhaus people were killed in concentration camps.[5]

Friedl Dicker-Brandeis also wrote for art journals, and as a painter exhibited on a regular basis. As an artist and an intellectual, political involvement came naturally to her, and like many of her generation, she identified with the Communist Party, since this organization seemed to provide the most effective means of combatting Fascism. As the pattern of Nazi anti-Semitism began to emerge Friedl was forced to obtain a visa to Palestine. Had she used it, she might have been alive today. She rejected the idea of flight, however, and chose instead to continue to work against the Nazis. What followed was inevitable. In December of 1942 she and her husband were apprehended and sent to Terezín where she remained for two years before being transferred to Auschwitz, her second and final destination.

The making of an art educator

Friedl Dicker-Brandeis's life had been dominated by two major obsessions—art and activist politics, with teaching occupying a minor position. In Terezín, she made an abrupt shift, abandoning her own creative life and keeping her spirit alive by continuing to engage in political study groups and work with children. It was the art educator within her that was to invest the final period of her life with the kind of meaning that enabled to her to cope with the events which lay ahead. At times she worked with existing groups such as the Home for Girls and in the Children's Hospital, but mostly she either created her own groups or worked with individuals. She taught wherever there was available space or children.

While Friedl is known best for her work with children, she also taught adults—as a lecturer and in the studio. To keep their minds occupied the inmates conducted their own informal "open" schools. Unlike many teachers who held informal seminars in philosophy, psychology and economics, Friedl refused the meager kinds of compensation accepted by her colleagues. In the words of one former student, "I think Friedl was the only one who didn't take a crust of bread for lessons. She simply gave herself to us."[6]

Friedl Dicker-Brandeis was not the only art teacher working in Terezín.[7] The thousands of drawings which are housed in Yad Vashem and the Jewish Museum in Prague and other centers suggest that not one, but many adults became actively involved in encouraging art activity. More references, however, have been made to Friedl than to any other teacher since she clearly was the only one interested enough in children's art to set down her ideas regarding the purposes of art activity, a methodology for instruction, as well as case studies of students. Teaching in Terezín called for great inventiveness as Friedl had to struggle with problems of space, time and supplies. She taught openly and in secret. Because of the crowded conditions and total lack of privacy, she gathered children wherever an area was unoccupied or open to temporary rearrangement.

Jeri Wehle[8] of the State Jewish Museum of Prague claims to have identified some 600 drawings out of the existing 4,000 as the results of Friedl's instruction, using as his basis for selection evidence of the influence

5. *Utopia Versuchein und Plastic.*

6. From a statement by Edna Furman, psychotherapist at the Cleveland State University, *From Bauhaus to Terezín*, Catalogue, The Art Museum of Yad Vashem, Jerusalem, Summer '90, Elena Makarova, Curator, p. 35.

7. Others included were Irma Lauschner and Dr. Baumelova.

8. Wehle, Jeri, "Teachers of Children," paper on file at the State Jewish Museum, Prague.

Ruth Weissová
(student of
Dicker-Brandeis),
Capital Letters, 1943-4,
pencil drawing, paper
21.5 x 27.5 cm,
State Jewish Museum,
Prague

of Johannes Itten, Friedl's former mentor. Wehle's conclusions may not be clearly substantiated by current research methods, yet if one adds Wehle's opinion to statements by witnesses and Dicker's own writings, a style of teaching begins to emerge. The edges are not always clear, but a basic approach to the teaching of art can be both discerned and studied.[9]

The drawings reveal Friedl's distinction between art instruction for teenagers and children on the elementary level. The work of the older students clearly reflects the content of Itten's basic design course and includes such subjects as exercises in line and texture, analytical studies of the work of European painters such as Lucas Cranach and Jan Vermeer, watercolor washes, contour line drawings and collages. She also taught puppetry, stitchery and observational studies of flowers as well as drawings based upon memory, personal interpretations of events, self-portraits and life drawing.

Friedl's philosophy with younger children can be viewed as what might be loosely termed "progressive." It was Rousseauian in that it rejected premature adult intervention of an academic kind, viewing children as changing, growing personalities whose integrity as individuals must, at all costs, be respected. It was child-centered as regards subject matter, employing the use of discussion, sense memory and strong personal association as key factors in the development of imagery.

The influence of Franz Cizek and Johannes Itten previously discussed were not the only influences on Friedl's thinking. The *Musische* movement, begun in neighboring Germany in 1870, was revived in the post WWII period and prior to the war was distorted by Nazi educators for their own ends. The members of the Musische movement opposed restrictive educational practices and were wary of industrial/technological pressures. They also favored craft activity and valued picture making as a means of self-realization through personal expression. The movement appealed to that sense of romantic idealism which is at the heart of any child-centered philosophy. In both Germany and Austria, these beliefs

were reflected in the formation of youth groups such as the Wandersvogel (hikers) and in Austria one group counted Viktor Lowenfeld among its members.[10]

Friedl was also familiar with Gusta Britsch's work on developmental stage theory and shared his view of the positive socializing effects of children working in groups as well as individuals. Friedl's methodology, from pictorial analysis for older children, to the free, unimpeded use of the inner and external events of a child's life as a source of imagery, to a respect for the child's stage of development, was already apparent to European art educators in the '20's.

Friedl's skill in blending these ideas with those retained from Itten's basic design course and her strong personal empathy for troubled and retarded children influenced, in turn, the teaching of one of her pupils and assistants, Edith Kramer, a distinguished art therapist. Kramer wrote in her memoirs, "Friedl could find ways to attract those children to creative activity. This, her gift, was subsequently used in her work with the children of Terezín. When in 1950, I began to work with abandoned and mentally retarded children, I took Friedl's methods for my basis. The drawings, poems, stories left by the Terezín children contain a tremendous vitality and are witness to their mental health. Compared to the works of unkempt, unloved, mentally traumatized children of American big cities, they seem advantaged "[11]

Because of Friedl's non-structured approach, it is more difficult to complete the identification of the work of younger children. This is consistent with her belief in the ability of children to find their own way to discover the means for expressing those impulses which reflect their uniqueness as individuals. In an earlier letter to Itten, she writes: "To direct the sparks of children's inspiration, those sudden illuminations, is criminal! Why are adults in such a hurry to make children like themselves? Are we really so happy with ourselves?"[12]

9. From the author's study of Friedl's students' work at the exhibition "From Bauhaus to Terezín: Friedl Dicker–Brandeis and Her Pupils." Yad Vashem, Jerusalem, Summer, 1990.

10. For a complete description of the Musische and other German influences of this period see *Musische Education: Its Origins, Influences and Survival in West German Art Education*, Lois Petrovitch-Mwaniki in the Conference Report of the 2nd Penn State Conference on the History of Art Education.

11. Kramer, E., "Memoirs of Friedl Dicker." *Bauhaus in Wien*, Exhibition Catalogue, Wien, 1989.

12. Personal archives of Elena Makarova.

Eva Brandeis
(student of Dicker-Brandeis)
Home in Landscape, 1944,
collage, paper, 20 x 25 cm,
State Jewish Museum, Prague

A brief inventory by this writer of the subject of children's work at the Yad Vashem and the State Jewish Museum is as follows: prison guards at work, funerals, and patients on stretcher. There were also pictures of a more positive nature such as flowers, illustrations for poems, nostalgia pieces of former life and personal fantasies. Friedl regarded the primary task of both teacher and adult as protector of the child against the callous indifference of the adult world. One could also say that she anticipated the work of Viktor Lowenfeld, as indicated by these quotations from her writings.[13]

From Part I

Drawing lessons should not intend to turn all children into artists. They should, however, maintain creativity and independence as a source of necessary energy in life, stimulate the imagination, and reinforce the individual's judgement and observational ability. Traditional drawing lessons are largely to blame for the loss of imagination and creativity in young people.

From Part II

With a child of ten, the teacher's main concern should be that it is not disturbed or distracted in his or her playful attempts at drawing. It is useless to teach the child, because in this self-centered age, it will refuse any interference in his drawing. In this age, painting and drawing are an important way of self-expression.

From Part III

The child over ten years starts to look for other ways to express himself; his world grows wider; it is no longer his fantasy world, but reality. Only at this point should drawing lessons begin, but they should never override the child's ideas. The technical skills of painting and drawing should fit the child's ability. Any instruction should leave the original concept of the picture to the child, but explain proportions, rhythm, light, darkness, plastic, dimensions, colour and the importance of exaggeration, understatement and composition.

Never direct children's ideas. One would lose access to their own world of imagination . . . If the instructor has sufficient experience of interpreting the drawings, they give him/her valuable clues for the child's emotional condition.

Part III also tells us that though Friedl was not against instruction-related to art concepts, she, like Lowenfeld, felt that formal instruction should be reserved for older children and then only in relation to problems of the student's own choice. She guided her students away from stereotypical thinking, stressed group work and urged the use of older talented students as teaching assistants. Of particular interest to this writer is her use of physical exercises to "free" the body to better prepare it for visual experience, thus sharing Itten's thesis that sensory experience should precede or be a part of any art activity—be it perceptual or imaginative in nature. She believed that for children design activities were a means to ends and that art began with life, not with a sorting of visual exercises based upon the training of adults. In this respect, she made an abrupt departure from Bauhaus instruction for professional training.

Elena Makarova, a Soviet emigre to Israel, who has done extensive research on Friedl and served as curator of a major exhibition at Yad Vashem (1990) has made the following comparison between Friedl's ideas and those of Itten:

Johannes Itten:	Friedl Dicker-Brandeis:
1. To liberate the creative forces and thereby the artistic talents of the students. Their own experiences and perceptions were to result in genuine work. Gradually, the students were to rid themselves of all the dead wood of convention and acquire the courage to create their own work.	1. Drawing must free and make full use of such sources and energies as creativity and independence; must strengthen the natural abilities of observation and appreciation of reality In determining children's paths we . . . sever them from their own creative experience. They are torn from their own tasks. On this path the child loses first the individual means of expression appropriate to his life experience, then the experience itself. Mastery of prepared forms too soon leads to the enslaving of personality.

13. Skochova, Jarmila, *The Literary Legacy of Friedl Dicker-Brandejsova.* (translated by Renata Kondyas).

Reneé Glucklichová
(student of Dicker-Brandeis),
Flowers, 1942-3,
24 x 34.5 cm,
State Jewish Museum,
Prague

Johannes Itten (continued):	Friedl Dicker-Brandeis (continued):
2. To make the student's choice of career easier. Here, exercises with materials and textures were a valuable aid. Each student quickly found the material with which he felt the closest affinity . . . that inspired him most to creative work.	2. Through independent choice, discovery, and exploration of form, the child becomes stable and sincere; his fantasy and intellect, gift for observation, patience, and later taste, develop. All of this ensures the road to Beauty.
3. The movements of the hands must be in harmony with the rhythm of the heart.	3. Rhythmic exercise must make both the artist himself and his hand inspired and supple Exercises allow children to break from the routine in both vision and thought . . . rhythm unites children, gives them a common impulse. [14]

One question which arises at this point is: since Johannes Itten was her mentor, what were the sources of his ideas? The answer to this lies partly in the fact that Itten was a primary school teacher prior to joining the Bauhaus and was well aware of the role of direct, sensory based experience discussed earlier by educational theorists such as Froebel and Pestalozzi. In his report for the physio-kinetic connection to the creative process, Itten may have been the first teacher in the history of art to associate the education of children with the training of professional artists.

The tradition with which Friedl identified began not with Itten, but as noted above, with Jean Jacques Rousseau in his "Emile." This view of childhood gathered momentum and began to assume its persona as psychologists began their search for universal patterns of graphic development. The Rousseauian paradigm also suggested the notion of the child as a model of such attributes as naivete, directness of vision and primitivism as seen in a positive sense. Meyer Shapiro describes this condition as "the child as the prototype of the painter and poet of genius." [14] This romantic vision made childhood a metaphor for the creative spirit operating at the highest level of productivity. By the mid-19th century, it made intellectual bed-fellows of an impressive galaxy of intellectuals, among them Baudelaire, Taine, Champfleury and Sainte-Beuve. Two of Rousseau's children also appear as keys to the understanding of Courbet's masterpiece, "Atelier" and appear as subjects in the work of Courbet's contemporaries such as François Bonvin and Pierre-Edouard Frère. [16]

Herbert Read inventoried the origins of visual efforts of children in both Great Britain and Europe in "Education through Art" (1943) and Viktor Lowenfeld, teaching at Hampton Institute in Virginia at the time of Friedl's transfer to Auschwitz, was already at work on "Creative and Mental Growth." Published just four years after Read's work, Lowenfeld's work stressed—among other ideas—the concept of art as a universal drive existing within a developmental framework. Friedl shared his conviction that children's growth patterns should be respected when teachers planned appropriate art activities.

Friedl Dicker-Brandeis was a woman of many parts who chose the teaching of art as the final focus of her energies. Her constraints were overwhelming, but her vision was both grand and passionate. She helped her students to set aside the horrors of the moment by giving them a sense of dignity through artistic experience. Had anyone suggested that such activities were "frills" both she and the children would have been stunned by their rationality of such an assumption. Friedl Dicker-Brandeis was an existentialist in that she created a centre of meaning at the heart of a universe that was hollow, absurd and finally, unbearable. That anyone could survive in such an environment is astounding; that anyone could create beauty in its midst is truly the mark of a hero.

Note:
This article was originally published in the *Journal of Art and Design Education* (Great Britain) Vol. 7, No. 3, 1988. The editors of this publication have graciously allowed me to expand the article in light of new information that has come to light since the original writing. —*A.H.*

14. *From Bauhaus to Terezín*, p. 6.

15. Shapiro, Meyer (1978) *Modern Art: 19th and 20th Centuries*, New York, George Braziller, p. 63.

16. See the *Bulletin of the Elvehjem Museum of Art*, 1981-1983, François Bonvin's "Seated Boy with a Portfolio," Gabriel Weisberg.

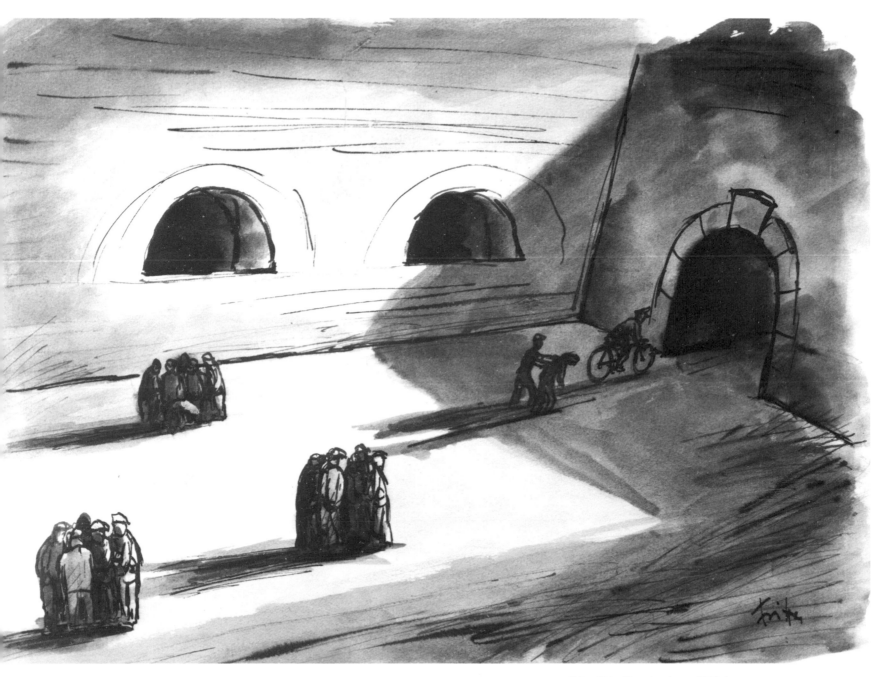

Fritta/Fritz Taussig, *Arrest*, 1943-4,
brush and India ink wash, paper, 37.5 x 49 cm,
State Jewish Museum, Prague

Short biographies of the Terezín artists

by Arno Pařík

translated by
Thomas Winner and
Irene Portis-Winner

Adolf Aussenberg
1914-1944

Born July 1, 1917, lived in Prague and worked in the film industry. An amateur painter. Deported to Terezín on February 12, 1942 (X, 476)[1] , where he worked in the Technical Department and drew scenes from Terezín life, sketches for theater productions and cartoons. Deported to Auschwitz on October 12, 1944 (Eq, llOQ), and was still seen there drawing.

Anonymous F. B.

It has not been possible to identify this artist. His small works, souvenir-like in character, indicate that he belonged to the circle of artists employed in the Terezín Artistic Workshops.

Ferdinand Bloch
1898-1944

Born August 15, 1898 in Austria and worked in Vienna as a graphic artist. In 1938 he emigrated to Prague, from where he was deported to Terezín on July 30, 1942 (AAv 594). Here he worked in the Drawing Office of the Technical Department. He clearly is one of the most significant Terezín painters, but much of his work has not survived. On July 17, 1944 he was arrested together with other painters for so-called "horror propaganda" (Greuelpropaganda) and was murdered in the Small Fortress on October 31, 1944.

Pepek Bondy

The author of anecdotal children's scenes from the life of the Ghettowache [2] and the gendarmes in Terezín. No other works by him are known.

Friedl Dicker-Brandeis
1898-1944

Born July 30, 1898 in Vienna. Studied at the Vienna Academy for Graphic and Applied Art, and in 1919-23 at the Bauhaus in Weimar (Germany). Active as a versatile designer for interior architecture and fashions in Berlin and Vienna. 1934 she emigrated to Prague and later lived in Hronov, Czechoslovakia. She was deported to Terezín on December 17, 1942 (Ch, 549), where she worked as drawing instructor in the children's homes. She perished in Auschwitz, where she was deported on October 6, 1944 (Eo, 167).

Charlotta Buřešová
1904-

Born in Prague November 4, 1904. Studied at School of Applied Arts in Prague, and then at Academy of Fine Arts, where she was graduated in 1925. Lived and worked in Prague until her deportation to Terezín (AAs 599) in 1942. Worked in "Lautscher" workshop, copying Rubens and Rembrandt paintings. Lived to see liberation of Terezín; has lived since in Prague.

83

1 These symbols represent the number of the transport. (Information provided by Arnošt Lustig. Translators' note)

2 The police of the ghetto self-administration (Transl.)

Karel Fleischmann
1897-1944

Born February 22, 1897 in Klatovy, Czechoslovakia. Studied medicine at the Charles University in Prague and worked as a dermatologist in České Budějovice. Since his youth he painted and wrote literary works and was one of the founding members of the avant-garde group "The Line". He was deported to Terezín April 18, 1942 (Akb, 68), where he worked with great self-sacrifice in the leadership of the health administration. In his free moments he drew, composed essays and poems and gave lectures. He perished in Auschwitz, where he was deported on October 23, 1944 (Et, 58Q).

Fritta (Fritz Taussig)
1906-1944

Born September 19, l906 in Višňová u Frydlantu in Bohemia; active as a cartoonist and graphic artist in Prague. In Terezín, where he was deported as part of the *Aufbaukommando*[3] on December 4, 1941 (J, 482), he became director of the Technical Department which became the center of artists and of unoffical art work. On July 17, 1944 he was arrested together with other painters for alleged "horror propaganda", and transferred with his wife, Hansi, and their three-year old son Tommy to the Small Fortress. [4] Together with Leo Haas, he was deported to Auschwitz on October 26, 1944. He perished there on November 8, 1944.

Leo Haas
1901-1983

Born April 15, 1901 in Opava, Czechoslovakia. Studied in Karlsruhe and at the Berlin Art Academy, and then worked as a portrait painter and lithographer in Opava. During the year 1939 he was a prisoner of the concentration camp Nizko. [5]. In Terezín, where he was deported December 30, 1942 from Ostrava, he was employed in the Drawing Office of the Technical Department. For his art work he was arrested on July 17, 1944 and, together with other painters, imprisoned in the Small Fortress. On October 26, 1944 he was deported to Auschwitz. He later passed through the concentration camps Sachsenhausen and Mauthausen, and was liberated in the camp Ebensee. After the war he worked as a cartoonist in Prague, and from 1955 on he was professor at the Art Academy in Berlin.

Leo Heilbrunn
1891-1944

Born July 16, 1891. Worked as advertising artist in Prague. Deported to Terezín August 10, 1942 (Ba, 886), and worked in the Drawing Office of the Technical Department. Participated in town planning and in the planning for buildings. His watercolors capture various ghetto scenes. Perished in Auschwitz, where he was deported October 28, 1944 (Ev, 689).

Helga Weissová Hošková
1929-

Born in Prague in 1929. Transported to Terezín at age 12 with her mother and father. Too old to participate in the children's drawing classes; drew independently. Also illustrated a book written by her father, *God Came to Terezín and Saw That It Was Bad*. In 1944 sent to Auschwitz and on to work camps; she and her mother survived the war and returned to Prague. After the war studied art with Emil Filla. Taught art for many years. Married, with two children and three grandchildren. Lives in Prague.

Anonymous E. K.

The State Jewish Museum has a number of amateur drawings signed with the initials E. K., done in Terezín between May 1943 to December 1944. All drawings depict scenes from the barracks of Building Q 314 and its close environs. These are done with great detail and obvious emotional engagement.

František Petr Kien
1919-1944

Born January 1, 1919 in Warnsdorf. In 1936-39 studied at the Prague Art Academy and, after the official closing of Czech institutions of higher learning, at the private graphic art school Officina Pragensis. In Terezín, where he was deported December 4, 1941 (J,855), became Fritta's deputy director of the Drawing Office. In addition to literary and dramatic activity, did many portraits of important camp personalities. Perished in Auschwitz, where he was deported together with his wife and parents on October 16, 1944 (Er, 359).

Anonymous J. L.

A small collection of drawings signed J.L., including some watercolors and ink and red chalk drawings, predominantly of views of barrack yards and the Terezín ramparts, have survived. According to the dating of these works, their author lived in the ghetto between March 1942 and April 1944.

Peter Löwenstein
1919-1944

Born in 1919 in Leitmeritz, Czechoslovakia. After finishing high school, moved to Prague where he studied engineering at Charles University. Sent in first transport to Terezín in Fall, 1941. Worked in technical department, executing drawings in pen and ink and watercolor. Deported to Auschwitz in 1944, where he perished.

3 The construction battalion charged with the preparation of the Terezín camp for the prisoners. (Transl.)

4 The Terezín prison. (Transl.)

5 The concentration camp Nizko in Poland near the Czechoslovak border was the first camp to which prisoners from Czechoslovakia were sent after the German invasion. (Information provided by Arnošt Lustig. Translator's note.)

František Mořic Nágl
1889-1944

Born May 18, 1889 on the estate Kostelní Myslová near Telč (Czechoslovakia). Studied at the School for Applied Art in Prague and the Academy of Art under Professor H. Schweiger. In Terezín, where he was deported from the town of Třebíč on May 22, 1942 (Aw,169), created a large group of watercolors and gouaches with scenes of barracks and courtyards. Deported from Terezín to Auschwitz with the last transport on October 28, 1944 (Ev, 1351), and perished there.

Joseph Eduard Adolph Spier
1900-1978

Born June 26, 1900 in Zutphen, the Netherlands. Deported to Terezín together with his family on April 22, 1943 (XXIV/l, 17). Worked in the Technical Department and participated in the "Beautification Campaign" with drawings for the propaganda album *Bilder aus Theresienstadt* [6] and drawings of scenes for the propaganda film, "The Führer Gives a City to the Jews." With the exception of his father, who was deported to Auschwitz, the entire Spier family survived in Terezín to the end of the war and returned to Holland. In 1951, Spier emigrated to the United States, where he died in 1978.

Otto Ungar
1901-1945

Born November 27, 1901 in Brno, Czechoslovakia. Graduated from the Prague Academy of Art and worked as a drawing teacher in the Jewish high school (Gymnasium) in Brno. In Terezín, where he was deported with his family January 28, 1942 (U, 971), he worked in the Drawing Office of the Technical Department. He was arrested with other painters on July 17, 1944, imprisoned in the Small Fortress, and quickly deported to Auschwitz. From here he came to Buchenwald in the death march of January, 1945. He died from results of his imprisonment on July 25, 1945 in the hospital in Bleikenheim near Weimar (East Germany).

Jiří Vogl

The engineer Jiří Vogl was sent to Terezín with one of the first transports in 1941. Here he worked in the Technical Department and was a member of the first Council of the Elders [7]. After liberation he became the director of the camp self-administration, charged with the closing of the Terezín concentration camp on May 10, 1945.

Ludvík Wodak
1902-1944

Born September 26, 1902 and worked as graphic artist in Brno. Deported to Terezín on April 8, 1942 (Ai, 531); seems to have been employed in the Technical Administration. Of his work, a collection of watercolors with Terezín scenes survives, as well as several delicate pen-drawn portraits. On October 16, 1944 he was deported to Auschwitz (Er, 757) where he perished.

Hilda Lohsing Zadikowá
1890-1974

Born June 23, 1890 in Prague. Received her artistic training in Prague and Munich and worked in Prague as an illustrator. In Terezín, where she was deported May 15, 1942 (Au-l, 458), worked, together with her husband Arnold Zadikow, in the "Lautscher" Workshop. Survived the war and, after stays in displaced persons camps and Israel, emigrated with her daughter to the United States, where she died in 1974.

František Zelenka
1904-1944

Born June 8, 1904 in Kutná Hora, Czechoslovakia. Graduated from architectural school in Prague and worked in Prague as a designer and author of posters for the avant-garde "Liberated Theater" and the theaters of E. F. Burian. Before being deported, he participated in the rehearsals of the children's opera "Brundibar" in the Jewish orphanage and worked on the exhibits of the war-time Central Jewish Museum in Prague.[8] Deported with his family to Terezín July 13, 1943 (Di,21); was in charge of the design of theater scenery. Perished in Auschwitz where he was deported October 19, 1944 (Es, 1155).

6 German: Pictures from Terezín. (Transl.)

7 Part of the Terezín self-administration. (Transl.)

8 This museum was organized by the Nazis to record the life of the Jews, as an ethnic group scheduled to disappear. (Transl.)

Checklist of the exhibition

Key to abbreviations:

LBI — Leo Baeck Institute

MJH — A Living Memorial to the Holocaust—
Museum of Jewish Heritage

SJM — State Jewish Museum

TM — Terezín Monument

Adolf Aussenberg, *Dream Scene*,
brush and India ink, paper, 25 x 35 cm,
1942-4, SJM

Adolf Aussenberg, *Prominent Apartment*,
pen and ink, watercolor, paper,
25 x 35.4 cm, 1944, SJM

Adolf Aussenberg, *Women in Café*,
brush and India ink, paper, 34.5 x 24 cm,
1944?, SJM

Ferdinand Bloch, *Blessing Coffins*,
charcoal, paper, 30.6 x 38.4 cm, 1943, SJM

Ferdinand Bloch, *Dissection*, charcoal,
paper, 39.5 x 54 cm, 1942-3, SJM

Ferdinand Bloch, *Lampshade*, pen, ink,
watercolor, paper, diameter 49.2 cm, 1943,
SJM

Ferdinand Bloch, *Queuing for Food*,
charcoal, paper, 39.5 x 53 cm, 1942-3, SJM

Ferdinand Bloch, *Night Burial*, charcoal,
paper, 29.6 x 30.5 cm, 1942, SJM

Pepek Bondy?, *Girlfriend/Joke*, pastel,
paper, framed, 30.5 x 22.5 cm, 1943, SJM

Pepek Bondy?, *Sewing pants/Joke*, pastel,
paper, framed, 31 x 22.5 cm, 1943?, SJM

Pepek Bondy?, *Smoking/Joke*, pencil,
watercolor, framed, 29 x 20.5 cm, 1943,
SJM

Friedl Dicker-Brandeis,
Flowers in a Glass of Water, watercolor on
paper, 30 x 22 cm, 1943, Collection of
Anna Sladkova

Friedl Dicker-Brandeis, *Woman with a
Cigarette*, pastel, paper, 1941-2, SJM

Friedl Dicker-Brandeis, *Portrait of a Man*,
pastel, paper, 1941-2, SJM

Charlotta Buřešová, *Kaufman-Karas/
Man Composing*, pencil, color, paper,
30 x 21 cm,1941-5, TM

Charlotta Buřešová, *Podlipská/
Portrait from Sketchbook*, India ink on
paper, 30 x 21 cm, 1941-5, TM

E. K., *My Office and Home*, colored
pencils, paper, 30.5 x 20.3 cm, 1943, SJM

E. K., *Prominent Apartment*, colored
pencils, paper, 26 x 33 cm, 1943-4, SJM

E. K., *Two-Tier Bunk*, pastel, paper,
22.2 x 26 cm, 1944, SJM

F. B., *View of Terezín*, pencil, watercolor,
framed, 8 x 10 cm, 1942-4, SJM

Karel Fleischmann, *Attic
Accommodation*, pen and ink wash, paper,
45 x 33 cm, 1943, SJM

Karel Fleischmann, *Attic Apartment*,
pen and India ink wash, paper, 33 x 45 cm,
1943, SJM

Karel Fleischmann, *Children with Adults*,
pen and India ink wash, paper, 15 x 21 cm,
1942, SJM

Karel Fleischmann, *Cultural Lecture*,
colored pen and India ink wash, paper,
25.3 x 30.5 cm, 1943, SJM

Karel Fleischmann, *Dream Scene*, pastel,
paper, 30 x 44 cm, 1943, SJM

Karel Fleischmann, *Egon Ledeč*, pencil,
paper, 15 x 21 cm, 1943, SJM

Karel Fleischmann, *Evening Soup*, brush
and India ink, paper, 64 x 70 cm, 1943-4,
SJM

Karel Fleischmann, *Family Apartment*,
pencil, paper, 35 x 50 cm, 1943, SJM

Karel Fleischmann, *Furniture*, pen and
India ink wash, paper, 42.5 x 50 cm, 1943,
SJM

Karel Fleischmann, *Hospital Scene*, pencil,
paper, 34.8 x 50 cm, 1943, SJM

Karel Fleischmann, *Loading Coffins*, pen
and ink wash, paper, 22.5 x 33 cm, 1943,
SJM

Karel Fleischmann, *Man with Suitcase*,
pencil, paper, 14 x 10 cm, 1943-4, SJM

Karel Fleischmann, *Moving from Sudeten
Barracks*, pen and India ink wash, paper,
33 x 45 cm, 1943, SJM

Karel Fleischmann, *Murmelstein*, pencil,
paper, 16 x 10 cm, 1944, SJM

Karel Fleischmann, *Music in the Park*, pen
and India ink wash, white tempera, paper,
48 x 148 cm, 1943, SJM

Karel Fleischmann, *Old Man with Cup*, soft
pencil, paper, 44 x 30 cm, 1943, SJM

Karel Fleischmann, *Registration*, brush, ink
wash, paper, 33 x 31.5 cm, 1943, SJM

Karel Fleischmann, *Registration
for Transport*, brush, ink wash, paper,
64 x 70 cm, 1943, SJM

Karel Fleischmann, *Schleuse*, pen and India
ink wash, paper, 22.5 x 33 cm, 1943, SJM

Karel Fleischmann, *Sifting of Garbage*, pen
and India ink wash, paper, 22.5 x 33 cm,
1943, SJM

Karel Fleischmann, *Soccer Scene*,
pen and ink wash, paper, 22.2 x 31.2 cm,
1943, SJM

Karel Fleischmann, *View of Terezín*,
brush and India ink, paper, 50 x 99.5 cm
1943, SJM

Karel Fleischmann, *Young Jewish Man*,
soft pencil, paper, 50 x 35 cm, 1943, SJM

Fritta/Fritz Taussig, *Arbeitseinsatz*,
ozalid print, paper, 38 x 80 cm, 1942, SJM

Fritta/Fritz Taussig, *Arrest*, brush, India
ink wash, paper, 37.5 x 49 cm, 1943-4,
SJM

Fritta/Fritz Taussig, *At Kavalier*, brush
and India ink wash, paper 47 x 35.8 cm,
1943-4, SJM

Fritta/Fritz Taussig, *Autumn/By the Walls
of the Ghetto*, pen and India ink, paper,
57 x 85 cm, 1943-4, SJM

Fritta/Fritz Taussig, *Baby Carriages*,
brush and ink wash, gouache, paper,
24.7 x 30.6 cm,1943-4, SJM

Fritta/Fritz Taussig, *Barackenbau*, ozalid
print, paper, 35 x 79 cm, 1942?, SJM

Fritta/Fritz Taussig, *Border of the Ghetto*,
brush, India ink wash, paper,
39 x 57 cm, 1943-4, SJM

Fritta/Fritz Taussig, *Coffins to Crematory*,
brush, India ink, paper, 42 x 59 cm,
1943-4, SJM

Fritta/Fritz Taussig, *Film and Reality*, pen
and ink, paper, 32 x 57 cm, 1943-4, SJM

Fritta/Fritz Taussig, *The Flood*, scratched
crayon, ink, paper, 41 x 58 cm, 1943-4,
SJM

Fritta/Fritz Taussig, *Furniture Storage*, brush, India ink wash, paper, 42 x 59 cm, 1943-4, SJM

Fritta/Fritz Taussig, *Hospital in Cinema*, brush, India ink wash, paper, 57 x 85 cm, 1943-4, SJM

Fritta/Fritz Taussig, *Kaffeehaus*, pen and ink, paper, 44 x 60 cm, 1943-4, SJM

Fritta/Fritz Taussig, *Kanalisationsbauten*, ozalid print, paper, 36 x 80 cm, 1942?, SJM

Fritta/Fritz Taussig, *Leaving Transport*, brush and India ink wash, paper, 46 x 70 cm, 1943-4, SJM

Fritta/Fritz Taussig, *Life in the Attic*, pen and ink, paper, 55 x 84 cm, 1943-4, SJM

Fritta/Fritz Taussig, *Life in Terezín*, pen and ink, paper, 55 x 84 cm, 1943-4, SJM

Fritta/Fritz Taussig, *Life of Prominent*, pen and ink, paper, 57 x 74 cm, 1943-4, SJM

Fritta/Fritz Taussig, *Moving of Sudeten Barracks*, pen and India ink, cardboard, 69.5 x 96.4 cm, 1943-4, SJM

Fritta/Fritz Taussig, *Night Arrival*, brush, India ink wash, paper, 42.3 x 59 cm, 1943-4, SJM

Fritta/Fritz Taussig, *The Shops in Terezín*, brush, India ink, paper, 57 x 84.5 cm, 1943-4, SJM

Fritta/Fritz Taussig, *Theatre in Yard*, brush, India ink wash, paper, 56 x 84 cm, 1943-4, SJM

Fritta/Fritz Taussig, *View of Terezín*, pen and India ink, paper, 59.3 x 44 cm, 1943-4, SJM

Fritta/Fritz Taussig, *The War*, brush, ink, pastel, crayon, paper, 75 x 105 cm, 1943-4, SJM

Fritta/Fritz Taussig, *Wasserwerksbau*, ozalid print, paper, 33.5 x 77 cm, 1942?, SJM

Leo Haas, *Caricature of Petr Kien*, India ink on paper, 42 x 30 cm, 1941-5, TM

Leo Haas, *Drafting/Technical Studio (Fritta, Kien)*, pencil, 36 x 53 cm, 1943, TM

Leo Haas, *Fritta Portrait*, India ink, paper, 44 x 30 cm, 1943, TM

Leo Haas, *Girl with Star*, pen and ink wash, paper, 42 x 25 cm, 1943, SJM

Leo Haas, *Inside Hospital*, pen and ink, paper, 38 x 50 cm, 1943, SJM

Leo Haas, *Jacob Edelstein*, tempera, cardboard, 61.7 x 48 cm, 194? SJM

Leo Haas, *Moving of Sudeten Barracks*, India ink, paper, 44.5 x 61 cm, 1943, TM

Leo Haas, *Park Before Hospital*, pen and ink wash, paper, 38 x 50 cm, 1943, SJM

Leo Haas, *Violinist in Bunk*, pencil and charcoal on paper, 28 x 21.5 cm, 1941-5, TM

Leo Heilbrunn?, *Book/Plans of Sudeten Kaserne*, pencil, 29.5 x 56.8 cm, 1942, SJM

Leo Heilbrunn, *Felix the Cat*, watercolor, paper, 30.5 x 43 cm, 1944?, SJM

Leo Heilbrunn, *Joiner's Workshop*, watercolor, paper, 28.4 x 43, 1943-4, SJM

Leo Heilbrunn, *Man and Dog*, watercolor, paper, 31 x 43 cm, 1944?, SJM

Leo Heilbrunn, *Terezín Overview*, ozalid, paper, 17.5 x 20.7cm, 1942, SJM

Leo Heilbrunn, *View of Prague Castle*, ozalid print, paper, 23.5 x 32.5 cm, 1944?, SJM

Helga Weissová Hošková, *Airing the Feather Beds*, pen, ink, watercolors, paper, 16 x 20 cm, 1943?, private collection

Helga Weissová Hošková, *Aryan Way*, pencil, paper, 15 x 22 cm, 1943, private collection

Helga Weissová Hošková, *At the Pump (German Lady with a Hat)*, colored pencil, paper, 16 x 22 cm, 1943, private collection

Helga Weissová Hošková, *Beautification for the Visit of the Red Cross Commission*, ink and watercolor on paper, 15.2 x 21.7 cm, 1944, MJH

Helga Weissová Hošková, *Cart/Hearse with Bread for Children*, watercolor, paper, 16.5 x 19.8 cm, 1942, private collection

Helga Weissová Hošková, *Catching the Flies and Bedbugs*, pen, India ink, watercolor, paper, 14 x 14 cm, 1943, private collection

Helga Weissová Hošková, *Concert in Barracks*, pen and ink, watercolor, paper, 16 x 19.5 cm, 1943?, private collection

Helga Weissová Hošková, *Cutting of Bunk Beds Before the Visit of the Red Cross Commission*, ink on paper, 25.4 x 21.6 cm, 1944, MJH

Helga Weissová Hošková, *Deportation with Relatives Held Back*, colored pencil, 1943, MJH

Helga Weissová Hošková, *Doctor Looking at Lice*, colored pencil, paper 20.5 x 13.5 cm, 1943, private collection

Helga Weissová Hošková, *Ill Woman Carried on Stretcher for Transport*, pen and ink, watercolor, paper, 16 x 19.5 cm, 1942, private collection

Helga Weissová Hošková, *Living Quarters in Barracks*, pen, ink, watercolor, paper, 16.5 x 19.5 cm, 1943?, private collection

Helga Weissová Hošková, *Into the School (forbidden teaching)*, pen, ink, watercolor, paper, 16 x 19.5 cm, 1943?, private collection

Helga Weissová Hošková, *Latrine*, pen, ink, watercolor, paper, 19 x 16 cm, 1943?, private collection

Helga Weissová Hošková, *Listing of the Possessions at Home*, watercolor, paper, 15 x 21.5 cm, 1943, private collection

Helga Weissová Hošková, *Opera in the Attic*, pencil, paper, 13.5 x 20.5, 1943, private collection

Helga Weissová Hošková, *Past, Present, Future*, pen, India ink, watercolor, paper, 22 x 30 cm, 1943, private collection

Helga Weissová Hošková, *Snowman (first drawing in Terezín)*, pen, ink and watercolor, paper, 13.5 x 21 cm, 1942, private collection

Helga Weissová Hošková, *Summons to Transport*, pencil, paper, 19.5 x 11 cm, 1942, private collection

Helga Weissová Hošková, *Transport of Bialystock Children Coming to Terezín*, pen, India ink, watercolor, paper, 14 x 21.5 cm, 1943?, private collection

Helga Weissová Hošková, *Washroom in the Barracks*, pen and ink, watercolors, paper, 14 x 21.5 cm, 1943?, private collection

Helga Weissová Hošková, *Wedding Anniversary of My Parents - 15th year (last anniversary)*, pen, India ink, watercolor, paper, 20.5 x 29.5 cm, 1944, private collection

Helga Weissová Hošková, *Women's Group to Meet Men by Cleaning Barracks*, pencil, paper, 14.5 x 21.5 cm, 1943, private collection

J. L., *Courtyard*, watercolor, paper, 22 x 30 cm, 1943, SJM

Petr Kien, *Bahnbau*, ozalid print, paper, 35.5 x 80 cm, 1943, SJM

Petr Kien, *Caricature of Dr. Borgzinner (with ship)*, pencil, India ink, paper, 34 x 24.4 cm, 1941-5, TM

Petr Kien, *Caricature of Dr. Elsner wearing hat (with nude)*, pencil, India ink, paper, 36.6 x 24.6 cm, 1943, TM

Petr Kien, *Caricature of Dr. E. Springer (with nude)*, pencil, India ink, paper, 32.7 x 24.8 cm, 1941-45, TM

Petr Kien, *Caricature of Dr. Knapp (with mountain climber)*, pencil, India ink, 34.2 x 24.3 cm, 1941-5, TM

Petr Kien, *Caricature of Dr. Plato (with scholar)*, pencil, India ink, paper, 34.1 x 24.5 cm, 1941-5, TM

Petr Kien, *Caricature of Dr. Stamm (with cellist)*, pencil and India ink, paper, 34.1 x 24.3 cm, 1941-5, TM

Petr Kien, *Caricature of Mrs. Fischer (with child)*, pencil, India ink, 32.6 x 24.5 cm, 1941-5, TM

Petr Kien, *Caricature of Surgical Assistant (with clown)*, pencil, India ink, paper, 32.6 x 24.6 cm, 1941-5, TM

Petr Kien, *Culture of the Greater Reich (parody)*, India ink, paper, 30 x 22 cm, 1941-5, TM

Petr Kien, *Edith Steiner-Kraus*, pen and ink, paper, 30 x 22 cm, 1943-4, SJM

Petr Kien, *Figures Working/Studies*, India ink, paper, 30 x 44.5 cm, 1941-5, TM

Petr Kien, *Gideon Klein*, pen and ink, paper, 30 x 22 cm, 1943-4, SJM

Petr Kien, *Pavel Haas*, pen and ink, paper, 30 x 22 cm, 1943-4, SJM

Petr Kien, *Landwirtschaft*, ozalid print, paper, 33.5 x 80 cm, 1942?, SJM

Petr Kien, *Mother and Child (son of Fritta?)*, India ink, paper, 29 x 20.5 cm, 1942, TM

Petr Kien, *Portrait of Mr. Stein*, chalk, paper, 63.4 x 46.2, 1941-5, TM

Petr Kien, *Produktion für die Ausfuhr*, ozalid print, paper, 30 x 51 cm, 1942, SJM

Petr Kien, *Produktion für Inneren Bedarf*, ozalid print, paper, 33.5 x 80 cm, 1942, SJM

Petr Kien, *Raphael Schächter*, pen and ink, paper, 30 x 22 cm, 1943, SJM

Petr Kien, *Renae Gärtner-Geisinger*, pen and ink, paper, 30 x 22 cm, 1943-4, SJM

Petr Kien, *Self-Portrait*, pastel, paper, 30 x 17 cm, 1941-4, TM

Petr Kien, *Theater in Courtyard/Circus*, ink wash, paper 22 x 30 cm, 1941-5, TM

Petr Kien, *Theater Scene*, pen wash, paper, 22 x 30 cm, 1941-5, TM

Petr Kien, *Viktor Ullmann*, pen and ink, paper, 30 x 22 cm, 1943-4, SJM

Petr Kien, *Violinist*, India ink, paper, 61.9 x 48 cm, 1937-9?, TM

Petr Kien, *Wolfi Lederer*, pen and ink, paper, 30 x 22 cm, 1943-4, SJM

Petr Kien, *Portrait of René Weinstein*, pastel, paper, 63.2 x 48.3 cm, 1943, TM

Peter Löwenstein, *Deportation*, watercolor and ink on paper, 21 x 29.7 cm, 1943, MJH

Peter Löwenstein, *Ghetto Theresienstadt*, pencil and crayon on paper, 29.5 x 21 cm, 1941-4, MJH

Peter Löwenstein, *Ghettowache*, pen and ink on paper, 20.5 x 29 cm, 1943, MJH

Peter Löwenstein, *Die Organisation des Ghettos I-VII*, pen, black and red ink, paper, 29.5 x 21.6 cm, 1941-4, MJH

Peter Löwenstein, *Die Stadt*, ink and color wash, paper, 29.5 x 21 cm, 1941-4, MJH

František M. Nágl, *Alfred Pick's Bunk*, gouache, paper, 39 x 30.4 cm, 1943, SJM

František M. Nágl, *Catholic Service*, watercolor, cardboard, 34.5 x 38.5 cm, 1943, SJM

František M. Nágl, *Count out People on the Walls*, tempera, paper, 23 x 33.5, 1943, SJM

František M. Nágl, *Jewish Service*, gouache, paper, 35 x 25.2 cm, 1943, SJM

František M. Nágl, *Wide Interior Bunks*, tempera, cardboard, 35 x 51.2 cm, 1942, SJM

Joseph E. A. Spier, *Bilder aus Theresienstadt*, book of eighteen scenes, print, watercolor, paper, 17 x 23.2 cm, 1944, SJM

Joseph E. A. Spier, *Theresienstadt*, watercolor on paper, 22 x 17.3 cm, 1943, LBI

Joseph E. A. Spier, *Aryan Way*, watercolor on paper, 22.2 x 31 cm, 1943, LBI

Joseph E. A. Spier, *Coat of Arms*, pen and ink, watercolor, 7.7 x 11 cm, 1942-4, SJM

Joseph E. A. Spier, *View Out Barracks Window*, watercolor on paper, 21.1 x 16.6 cm, 1943, LBI

Otto Ungar, *After Transport Departs*, gouache, paper, 50.4 x 69.5 cm, SJM

Otto Ungar, *Improvised Prayerhall*, pencil, watercolor, 31.2 x 22.4 cm, SJM

Otto Ungar, *Numbering in the Valley of Bohušovice*, brush and ink, paper, 42 x 61 cm, 1943-4 TM

Otto Ungar, *Old Woman with Cup and Spoon*, gouache, 62.3 x 43.5cm, 1943-4, SJM

Otto Ungar, *People Queuing for Food*, pen, ink, watercolor, paper, 44 x 60 cm, SJM

Otto Ungar, *Queuing up for Food/Funeral*, charcoal, gouache, paper, 22 x 29.8 cm, 1942, TM

Otto Ungar, *Storm in Station Street*, gouache, paper, 43.3 x 57 cm, 1941-5, SJM

Otto Ungar, *Terezín Square*, gouache, paper, 44 x 59.6 cm, 1943-4, SJM

Otto Ungar, *Two Blind Men from Q 307*, watercolor, paper, 44 x 60 cm, SJM

Otto Ungar, *Two Blind Women*, gouache, paper, 57 x 40 cm, 1943, SJM

Jiří Vogl, *Plan of Hearse for Beautification*, pencil, paper, 31.5 x 45 cm, 1944, SJM

M. Weinerová, *Arriving at Train Station*, pencil, paper, 20.5 x 29.3 cm, 1941-5, TM

Ludvík Wodak, *Hospital Courtyard*, watercolor, paper, 22 x 30 cm, 1944, SJM

Ludvík Wodak, *Self-Portrait*, watercolor, paper, 40 x 30 cm, 1944?, SJM

Hilda Zadikowá, *Book with cover and eight pages*, pencil and watercolor, paper, 15 x 20 cm, 1944?, SJM

Hilda Zadikowá, *Flower Painting*, pencil and watercolor, paper, 16.6 x 14.3 cm, 1943?, SJM

Hilda Zadikowá, *Folk Scene*, pencil and watercolor, paper, framed, 12 x 27.5 cm, 1943?, SJM

Hilda Zadikowá, *Game Cards*, ink, paper, 12 cards, (eleven at 4.7 x 3.9 cm and one at 4 x 4.5 cm) 1941-5, TM

Hilda Zadikowá, *Scenes from "Prodaná Nevěsta"*, pencil and tempera, paper, framed, 14 x 28.5 cm, 1943, SJM

Hilda Zadikowá, *Terezín Calendar*, pen and ink, gouache, paper on cardboard, 33 x 46.5cm, 1945, SJM

František Zelenka, *Congratulations with Brundibar Scene*, pen and watercolor, paper, 35 x 52 cm, 1944?, SJM

Unknown, *Humor ist...*, tempera, paper, 14.5 x 14.5 cm, 1944?, SJM

Unknown, *Plan of Baby Carriage*, pencil drawing, paper, 30 x 42.5 cm, 1944, SJM

Unknown, *Putzkolonne*, print, cyklostyl, paper, 29.5 x 21 cm, 1942-5, SJM

Unknown, *Speisen werden...*, ink, paper, 18.5 x 24 cm, 1942-5, SJM

Unknown, *Street Map*, watercolor, ozalid, 55 x 62.6 cm 1942, SJM

Unknown, *Verteilungsstelle*, print, cyklostyl, paper, 29.5 x 21 cm, 1942-5, SJM

Drafting Studio Artists, *Book of Views of Terezín* (9 by Haas, 3 by Kien, 4 by Fritta, 1 unknown) pencil, watercolor (unknown in pencil and crayon), 1944, TM

Children

Eva Brandeis, *Home in Landscape*, collage, paper, 20 x 25 cm, 1944, SJM

Renee Glucklichová, *Flowers*, watercolor, paper, 24 x 34.5 cm, 1942-3, SJM

Elly Herrmannová, *Landscape*, watercolor, paper mounted on cardboard, paper is 21 x 28 cm, 1943-4, SJM

Hana Justitzová, *Color Drawing*, pastel, paper, 20.5 x 29.5 cm, 1942-4, SJM

Vera Lowyová, *House in Landscape*, collage, paper, 24 x 29 cm, 1943-4, SJM

Greta Schlesingerová, *Exercises*, watercolor, paper, 35 x 25 cm, 1944, SJM

Ilsa Taskierová, *Family Interior*, colored pencils, paper, 25 x 35 cm, 1943-4, SJM

Ruth Weissová, *Capital Letters*, pencil drawing, paper, 21.5 x 27.5 cm, 1943-4, SJM

Design:
Kohn/Cruikshank, Boston

Photography:
Clive Russ

Printing:
Mercantile Printing Company,
Worcester

Type:
Set in Adobe Janson,
on a Macintosh computer, and output
by Typographic House, Boston

Paper:
Monadnock Dulcet,
100lb smooth text

Massachusetts College of Art
621 Huntington Ave.
Boston, Massachusetts 02115

ISBN 0-9628905-0-2

T3-ACI-356